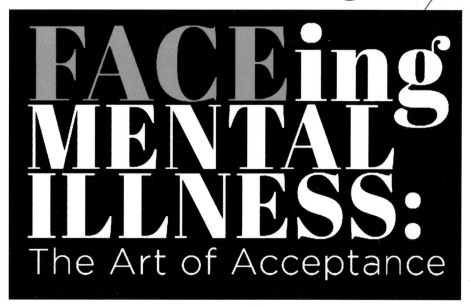

FACEing MENTAL ILLNESS: The Art of Acceptance

By Carrie Seidman and the artists of the FACEing Mental Illness project

Portraits by *Sarasota Herald-Tribune* photojournalists

Artwork photography by Wayne Eastep

the Peppertree Press
Sarasota, Florida

For information regarding permission, call 941-922-2662 or contact us at our website:
www.peppertreepublishing.com or write to:

the Peppertree Press, LLC.
Attention: Publisher
1269 First Street, Suite 7
Sarasota, Florida 34236

ISBN: 978-1-61493-529-2
Library of Congress Number: 2017908788
Printed July 2017

On The Cover: INUNDATED AND OVERWHELMED

BY AMANDA GAUDRÉE

"If you think that my sculpture is overwhelming or has too much going on, then you would be right. This is my ADHD brain. It's overwhelming, it's exhausting and confusing; it is too much and too little. I am 22 now and am in my final year at New College despite my severe ADHD. My ADHD has been both a blessing and a curse; a blessing because it helped me find my calling (my goal is to go into ADHA research and therapy) and a curse because I put so much effort into everything I do and yet that effort rarely shows through. This sculpture was designed to be so overwhelming to give you some sense of what it is to have ADHD. This piece is filled with hidden gems. As such, I invite you to take a closer look at my sculpture through the watch face on the side of the brain. The outside of the brain is just one layer, hiding an intricate world inside."

Dedication

To all of the artists in the FACEing Mental Illness project and to the community of Sarasota, which generously supported our goal of eliminating discrimination against individuals with mental health conditions.

SARASOTA COUNTY GOVERNMENT
Sarasota, Florida
Proclamation

WHEREAS, "FACEing Mental Illness: The Art of Acceptance," is a collaborative, local art project intended to help reduce the stigma associated with mental health conditions and build a more inclusive, accepting community that refuses to discriminate against those with mental health issues; and

WHEREAS, the project included free monthly art workshops at which anyone with a mental health condition, diagnosed or not, was invited to create a self-portrait exploring their feelings about their challenges and how others perceive them, and the artists' personal stories have been running weekly in the Herald-Tribune; and

WHEREAS, the artwork will hang in the Selby Library throughout the month of March, and there will be several public events, including a nationally recognized guest speaker and a panel discussion exploring what is being done in Sarasota to assist those with mental health challenges.

NOW, THEREFORE, WE THE BOARD OF COUNTY COMMISSIONERS OF SARASOTA COUNTY, FLORIDA,
do hereby proclaim March 2017 to be:

FACEing MENTAL ILLNESS MONTH

PRESENTED this 28th day of February, 2017.

Paul Caragiulo *Chair*
Sarasota County District 2 Commissioner

Nancy C. Detert *Vice Chair*
Sarasota County District 3 Commissioner

Michael A. Moran
Sarasota County District 1 Commissioner

Alan Maio
Sarasota County District 4 Commissioner

Charles D. Hines
Sarasota County District 5 Commissioner

Karen E. Rushing
Clerk of the Circuit Court and County Comptroller

Photo by Matt Houston

Introduction

 In the fall of 2016, *Sarasota Herald-Tribune* staff writer Carrie Seidman launched an art/journalism project, in conjunction with her fellowship from the Carter Center for Mental Health Journalism, aimed at eliminating prejudice against individuals with mental illness.

FACEing Mental Illness: The Art of Acceptance invited individuals within the community with a mental health condition of any kind, to create a self-portrait exploring their feelings about their challenges. A series of free workshops were held monthly, where art supplies and professional guidance were available to all. Many participants also chose to share their mental health journeys in depth, through interviews and in videos, and their stories ran weekly in the Herald-Tribune.

Hundreds of community members volunteered time or gave generously to help underwrite the costs of the supplies, workshops, transportation and a film documenting the project's progress. Dozens of local business contributed in-kind services, from framing to refreshments. The project culminated with a month-long exhibition of all the project artwork at the Selby Public Library in downtown Sarasota in March 2017.

In the following pages, you will find many of the stories and most of the artwork created for the project. It is our hope that community efforts like this one will help change our culture's attitudes about mental illness and promote better mental health for everyone.

JESSICA SWAFFORD

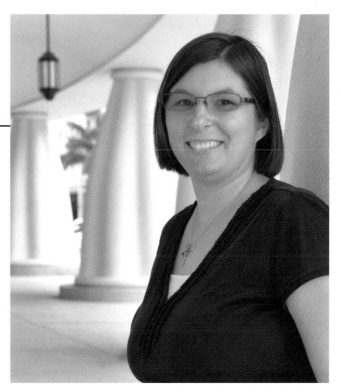

Photo by Mike Lang

Jessica Swafford lay on the floor of her darkened office. From where she was, she could see her phone lighting up. Ringing and stopping and ringing again. She knew it was her husband, Darrell. She knew he must be worried. She knew she should answer. But, paralyzed by depression, she found herself literally unable to reach for it.

"I'd see him calling, the phone would light up, I knew it was him, and I just could not answer," says Swafford, a wholesome looking woman with a neat brunette page boy and deep brown eyes behind glasses. "And it wasn't just once. It happened many times."

That was about five years ago and it sent Swafford, a Ringling College of Art and Design graduate, to the first of several psychiatrists. Thus began what the 30-year-old calls "the Olympiad of medication," an ongoing effort to find the right drug or combination of drugs to even out the manias and extreme depressions of her subsequently diagnosed bipolar disorder.

Thus far, she's tried and rejected seven; either they didn't work at all, ceased working after a period of time or had intolerable side effects. Today she takes 10½ pills daily – everything from an anti-psychotic to something for the heartburn that is a byproduct of all the others. It has helped a great deal, she says. But not enough to allow her to return to work, nor to live a life without self-imposed restrictions.

"The medication has made a huge difference in my life," Swafford says. "But the future is still a very big question mark. My illness dictates what I can and cannot do."

Worst of all are the occasions when she experiences delusions – not auditory hallucinations, but "more like a movie playing in my head that I can't stop" in which "bad things happen to people I love." Sometimes the illusions are so disturbing, she can't bring herself to divulge all the details to her doctor or even her husband, though she knows he would listen and be understanding, as he always is.

And even with medication, her moods and energy levels continue to fluctuate with frustrating regularity. Week-long periods of mania, insomnia and busy-ness are followed by weeks of lethargy, inertia and desolation.

"I call it 'feast or famine,'" she says. "It's either 'make-make-make, do-do-do' and then collapse, or it's nothing at all."

When she's on an upswing, she talks nonstop, cleans every inch of the house or focuses with oblivious intensity on her latest art project. When she's at the other end, it's all she can do to make sure her two toddlers, Maximus, 4, and Kaylee, 2, are fed a bowl of cereal and dressed.

"It's heartbreaking to have your kids beg you to play with them and … you just can't," Swafford says. "On the bad days, I

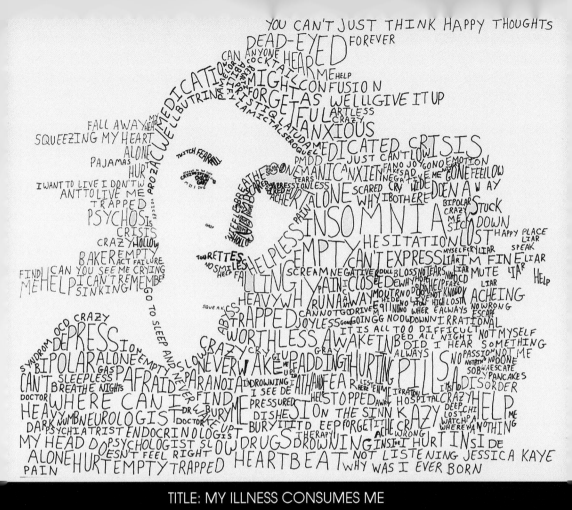

TITLE: MY ILLNESS CONSUMES ME

t first, I wanted my portrait to represent, 'I Am More Than My Illness.' People always s
at, right? And it's such an encouraging thought. But halfway through, I realized that
rtrait actually reflected my reality: That my illness consumes me. It consumes my life
ctates what I can do, when I can do it, and how well I can do it.

ly illness is complex, faceted, and varied. I don't think anyone's can be summed up
e word or diagnosis'

nfortunately, my illness is part of who I am.

om afar, I look just fine. It's when you get a little closer that you begin to see wh

just sit there with them and think, 'Well, they're in the house. They're safe. They're fed. That's all I can manage."

Her own childhood was spent on an Air Force base in Germany, where her mother was a school teacher and her father held a civilian position directing logistics for helicopters and missiles. An emotional child, she had frequent crying jags and sometimes hid for hours if things didn't go her way. Early in elementary school, when she began to "throw my hands up in the air and squeak," she was diagnosed with Tourette's syndrome. Her parents put both her and her two-years-younger brother, who'd been diagnosed with Attention Deficit Disorder, into therapy, but she doesn't recall any of it as especially traumatic or alienating. In fact, many of those early signs she learned of only recently, when her mother belatedly shared her childhood medical records.

She learned to control the Tourette's and her mood swings, in part, by channeling her energy into art, "which kept my hands busy making things and produced something tangible when I was done." When she had insomnia at night, which was not infrequently, she'd get out of bed and draw. A good student academically, she took every art class she could in high school.

With graduation looming, and her parents expecting her either to go to college or into the military – she rejected the latter because "I'd seen too many friends move every two years and I wasn't going to do that" -- she Googled art schools and found RCAD and a school in Savannah, Georgia. Accepted at both, she made the decision to move, at 17, to Sarasota – away from family for the first time and "just in time for (hurricanes/tropical storms) Charley, Ivan, Jean and Frances."

Amidst the uber-talented RCAD student population, Swafford quickly realized "I wasn't that talented and wouldn't make it in the art field after school." Nevertheless, she "loved, loved, loved" her time there and when, through friends, she was introduced to Darrell, who lived in Wachula, she quickly fell in love with him too and commuted back and forth regularly. Within a month of her graduation, they married and she moved to Hardee County, where Darrell is the head of IT for the public school system.

Swafford's husband and her mother, to whom she speaks by phone daily, are the bedrock of her support system. She speaks of Darrell with a kind of reverent disbelief, knowing the challenges her illness has presented.

"He has never made me feel like a burden, though I'm sure I have been," she says. "And when we talk about it, it's always 'we' need to get this under control, not 'you.'"

When Swafford became pregnant, she faced a torturous dilemma: go off her medications and risk a devastating "break" or stay on them and risk the health of her child. Both times, she chose to go off her medications and both times, things did not go well.

"The second time I went off everything and no doctor would even see me," she says. "Thank goodness, my kids were born with no problems. But both of my pregnancies were miserable, the worst times of my life, especially the depression. Even though I didn't want to, I had my tubes tied after that. Neither me nor my husband felt it was safe to get pregnant again."

Swafford has applied several times for disability status but has thus far been unsuccessful in obtaining it. A job, at this point, seems unfeasible. Often, she says, she feels like "a useless person, who's not contributing to my family or my community." When others ask why she isn't working, their responses, meant to be empathetic, only make her feel worse.

"A lot of people say, 'Oh yeah, I'm like that too,' which makes me feel like nothing's wrong and I'm just being a hypochondriac," she says. "They're trying to relate, but it's more like they're saying, 'You're a wimp.'"

The one thing she can still get excited about is doing art. Photos on her phone reveal she is prolific, if not single-minded, with sculptures alongside drawings, murals, graphic designs and even a race car invitation to a party for her children.

"When there's a blank page all I can think is, 'What am I going to do with it?'" she says. "There are so many options. When I do my art, I have tunnel vision. There is nothing else that exists but what I'm working on."

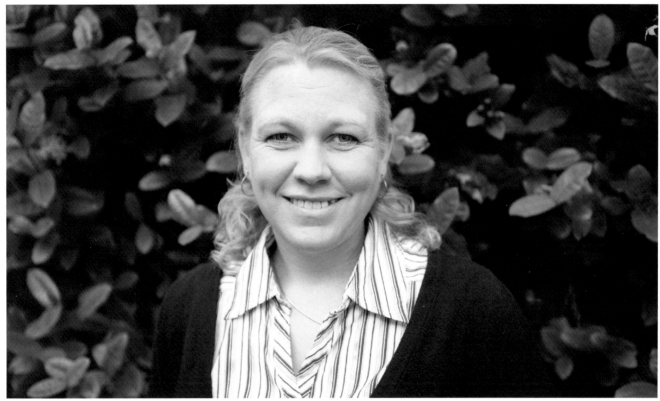

Photo by Rachel S. O'Hara

AMY SELL

Something about Amy Sell's Goldilocks blonde curls, discreet wardrobe and demure avoidance of direct eye contact brings to mind women of a simpler era. But her life has been anything but uncomplicated.

According to stories her parents tell about their eldest daughter, Sell was a happy, voluble child, singing songs and telling stories as she grew up on the family's dairy farm in Wisconsin, eventually joined by two younger sisters. But not long after the family lost the farm and moved to Sarasota when she was 7, her behavior changed precipitously.

"I don't know what caused it, but I became painfully shy and wildly anxious," says Sell, now 36. "I was very awkward and didn't really like to be around people. And I started to have some difficulty with concentration."

Nevertheless, she was a diligent student who did well in school and never got into trouble. Her family's philosophy was that if you put your head down and worked hard, all things were possible, and Sell took it to heart. She graduated as an honors student from Riverview High School, went on to a degree in political science and criminology from the University of Florida and was accepted to the very competitive law program at Gainesville in 2002.

Law school is stressful for anyone, much less someone with difficulties focusing and concentrating. Still, Sell managed well enough for the first year and a half. Then a series of incidents — including "being on the receiving end of a

crime" and the loss of a friend to drowning — pushed her over the edge.

The multitude of scars on both her arms, from wrists to shoulders, remain as testament to the severity of her breakdown. Doctors saved her life with transfusions and gave her the first of what would become a long list of mental health diagnoses over the past 15 years. Major recurrent psychotic depression. Social anxiety. PTSD. Schizoaffective disorder. Social phobia. Borderline personality disorder.

"I'm an overachiever," Sell laughs, with characteristic self-effacing humor.

Placed on an anti-depressant and an anti-psychotic, she returned to law school. But faced with a routine background check by the Florida Board of Bar Examiners, which screens all potential law candidates for "character and fitness," she simply could not bring herself to reveal her history.

"They were asking for the hospital's records and diagnosis," she remembers. "They said, 'If you don't tell us anything, you will be permanently barred from applying to the Bar ever again.' At that point I was already sort of doubting myself, and I just couldn't bring myself to check the box. I decided I'd just find something else."

She withdrew her application, "with prejudice," meaning the door to becoming the criminal defense lawyer she once hoped to be would forever be closed.

She returned to Sarasota and cycled through a series of jobs, each one a step down from her aspirations. Eventually she took a position as a clerk in a Publix deli department, where at least she could prove her work ethic.

But nothing lasted very long. More than once, "medication misadventures" led to her being re-hospitalized, most recently in 2013, when she overdosed on her anti-psychotics "mostly out of desperation."

"I had some ideas I knew were not true, but were unshakable," she says. "One was the feeling that my death was imminent. And in a way, that felt like kind of a relief."

This time, the doctors recommended electric shock treatments. Sell, whose level of comprehension at the time was vague, thought she was receiving a cardiac treatment that would "offer the benefit of exercise when I was sleeping." As she lay on a hospital table a doctor explained the procedure to attending medical students, and Sell thought it sounded "like something from the 19th century." Nevertheless, desperate to feel better, she submitted.

She received the treatment for six months on a tapering schedule. Her doctors and a co-worker thought it helped; her parents did not. Sell herself isn't sure.

For the past two years she has lived a quiet, spare and private life, relying on disability payments and part-time jobs that make no real use of her intellect or sensitivity. In her current position taking donations at Goodwill, she likes to imagine the stories behind the items that are dropped off — a wallet containing the ID of someone who died far too young; the vintage purse, a gift from a mother that an elderly woman can barely bear to let go of.

The house Sell rents from her family is full of her own vintage treasures, mostly discovered on her frequent trips to local flea markets. It's there she also finds the multiple bracelets that always adorn her wrists; they give someone an excuse not to be embarrassed when they stare too long at her arms, she says.

She volunteers regularly for SURE, an interfaith organization committed to justice, fairness, equity and peace, and is quick to offer assistance to anyone in need, from a homeless man to a child struggling with a shoelace. But, other than the occasions when she posts videos on social media of herself playing her guitar, or shares one of the poems she's written with the walking group she joins on Saturday mornings, she keeps her gifts to herself.

When you ask what she'd like people to know about her, she answers, but looks away.

"That I'm not a threatening person," she says. "The only person I've ever hurt was myself. I never even complain about bad service, because I wouldn't want anyone to do that to me. I'm someone who needs a lot of forgiveness, so I tend to be over-forgiving of others."

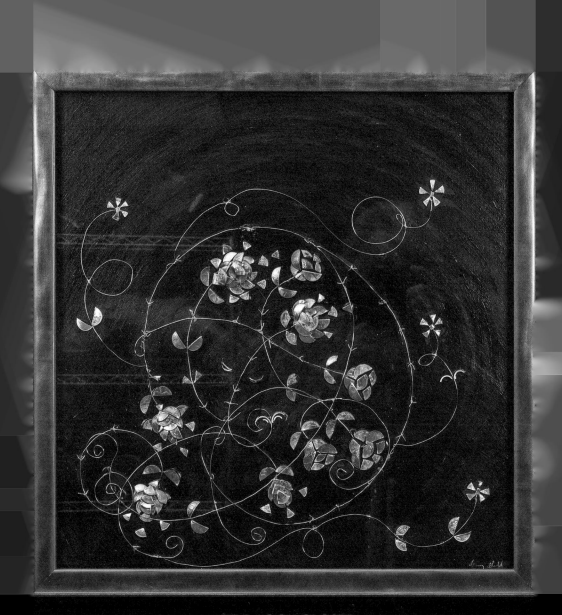

TITLE: LOOK CLOSER

...to illustrate how cut-up coins (pennies and dimes) can be part of a nice pict...
...omic value has been diminished. Maybe the metaphor is pretty obvious, bu...
...onfused, the coins represent people regarded as irreparably damaged o...
...le to no economic value to society. Also, there is a face in the picture, but it...
...lt to notice if you aren't looking for it. Yes, that's a metaphor too."

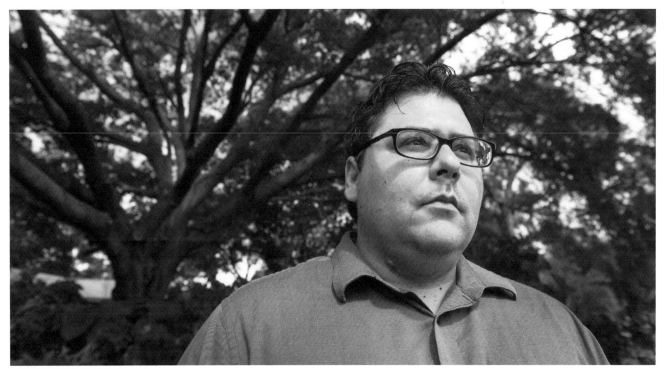

Photo by Dan Wagner

CHRISTOPHER COURNOYER

Not long ago, Chris Cournoyer watched some film his parents had taken when he and his two older brothers were children. He scrutinized the footage of his happy, busy, younger self, intent on finding a sign that might have indicated what was to come.

"I felt like I could tell even then," says Cournoyer, now 39, sitting in the room of his parents' Sarasota home that serves as his bedroom, art room and music studio. "You could see so many things jumping through this little kid's mind at the same time."

But no one predicted the onset of mental illness — later diagnosed as bipolar and schizoaffective disorder — that usurped most of Cournoyer's early adulthood. Now in recovery and stable, he has shed the crutches — smoking, alcohol and drugs

— that kept him alive through those traumatic years and is reconnecting with his gifts as an artist, a musician and a teacher.

Born to a full-blood member of the Rosebud Sioux tribe of South Dakota and a former secretary who became his second wife, Cournoyer moved with his family to Sarasota at the age of 4 and remembers his early years as "really good, really happy." He sang in the school choir at Julie Rohr Academy, played baseball and learned to play the guitar and bass. But after entering Cardinal Mooney High, he began to realize "I had some problems."

"I didn't really fit in," he says. "I ran with the kids who were mean and rabble-rousers, but I was in honors classes. After a while I had no close friends because I was trying to be everything to everyone."

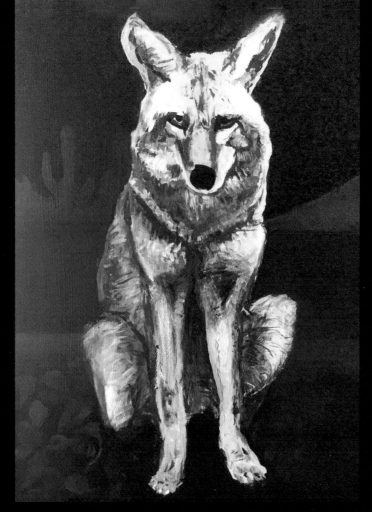

TITLE: WHAT THE COYOTE KNOWS

"I am a Lakota artist. I can relate to the coyote. The coyote in Lakota symbolism is one of being a trickster. He is generally associated with views which are considered wisdom, but all kinds of strange behavior is also noted in Coyote. I have not made art in the last 15 years, except doodles on notebook paper. I studied art and jazz at the University of South Florida. But just before I graduated, I began struggling to cope with reality. My battle with mental health has led to amassing many strange situations and problems lived out which are very dark. Some of Coyote's fables and misadventures are equally dark."

He took up reading Biblical texts, plunging into the Catholicism with which he'd been raised as well as the spiritual texts of his Lakota heritage. His connection to both felt profound, but his personal direction was obscure. Uncomfortable in his own skin, awkward around girls and imagining "I wasn't good enough," he exercised compulsively, became bulimic, and was besieged with guilt and self-loathing.

Cournoyer followed his brother to college where they formed a band. In school, he met his former wife, an African-American woman with whom he would forge "the only serious relationship I've ever had" and followed her when she transferred to another school.

They were misfits who found in each other a lifeline, but they fed their insecurities with alcohol and drugs. After nearly six years together — and against the wishes and advice of his parents — they were married. But when Cournoyer began to show signs of disconnecting with reality, instead of seeking help, his wife, a pharmaceutical rep, gave him random samples of mental health drugs, exacerbating an already fragile situation. Eventually a steady stream of music gigs wound up being more appealing than academics and he left school before finishing his degree.

The next decade became a blur of cities, manias, medications, jails, doctors and depression. Birmingham, Miami, Washington, D.C., Fort Lauderdale. Abilify, Geodone, Risperdal, Clozaril. In and out of a revolving door of psychiatric units and treatment programs, pawning thousands of dollars in possessions to make his next escape and running from hallucinations and his family's help. Once, picked up by police, he begged them to put him in prison so he would be away from anything electronic, convinced that his mind was being manipulated by unseen forces determined to harvest his organs. Somewhere along the way he finished his degree and got a divorce; neither stemmed the downward spiral.

In 2013, convinced that killing himself would be less painful than the tortures his brain envisioned, he attempted suicide.

"I felt there was no hope," Cournoyer says. "I felt shoved away in a corner. I remember reading about this walnut tree in France and people would come pick its nuts and take the interesting tidbits. But the tree never went anywhere and eventually there was nothing left on its branches. That felt like me."

He retreated to a refuge of his past, sequestering himself in his childhood bedroom, filling books and bins with sketches that explored artistically what no one seemed to be able to understand.

He kept clean of drugs and alcohol and quit cold turkey after 13 years of chain smoking. He drove across the state to buy a vintage press so he could teach himself to make art prints. He pulled out his old bass, cracked and patched, and found a new friend, someone who had waged his own mental health battles, to jam with once a week. Both of them hoped they would play in public again one day.

There are still "good days and bad days." Too happy or too sad — either way "it's unhealthy," Cournoyer says. For the sake of serenity, he keeps his life simple, quiet, devoid of drama. He doesn't often go out socially; his medications make him crave food and sleep more than normal. A current goal is to tackle his weight gain, the result of years of the most typical side effect of anti-psychotics. He doesn't advertise his health issues, but he doesn't hide them either.

"I don't have a problem telling people," he says. "I know it's never been my fault. But it's been a hard thing to talk about without getting blamed."

Last summer, through a friend who eased the application process, Cournoyer got a job teaching art to children at a summer camp. He loved it; the kids loved him. They called him "artist." As in, "Hey, Artist, what are we going to do today?" "Hey, Artist, did you bring your guitar today?"

Sometimes, while they worked, busy and happy just as he was at their age, he would play for them. The song he played most often was "Don't Worry, Be Happy."

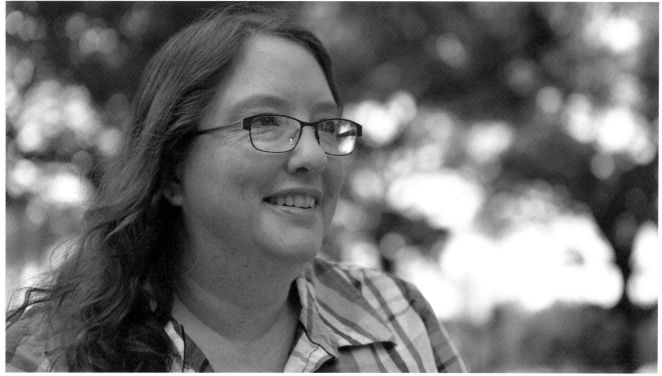

Photo by Mike Lang

ROBIN SNUTTJER

Ask Robin Snuttjer when she knew her father had a mental illness and before you can finish the question she responds, "Before I can remember."

"He had his first break at 29, when my mother was pregnant with me," says Snuttjer, 45, an only child whose parents divorced when she was a toddler. "When I was in fifth grade, he came to the house psychotic and I hid in the bathroom while my mother called the police."

Eventually her mother explained that her father had a chemical imbalance in the brain that "made him do things he wouldn't normally do." So, she said, did her brother, Snuttjer's uncle, who had been diagnosed with bipolar disorder.

"Between the two of them, there was mental illness on both sides of the family," Snuttjer says. "For a long time I was very worried it would happen to me. Just when I got over that fear was when it happened."

A socially awkward but intellectually gifted child — as an adult she became a member of MENSA, the "genius" organization — Snuttjer was educated at an elite boarding school in the Northeast and attended an exclusive women's college in Georgia, where she earned a degree in biology. For several years she worked in a laboratory, sequencing DNA, then moved to a computer technical support job.

But there always seemed to be "problems." During a solo trip to Scotland in 1999, her mental state, already fragile, began to deteriorate beyond the quirkiness that had caused her to lose several jobs and retain few friends. At exactly the same age as her father's diagnosis, she was hospitalized and,

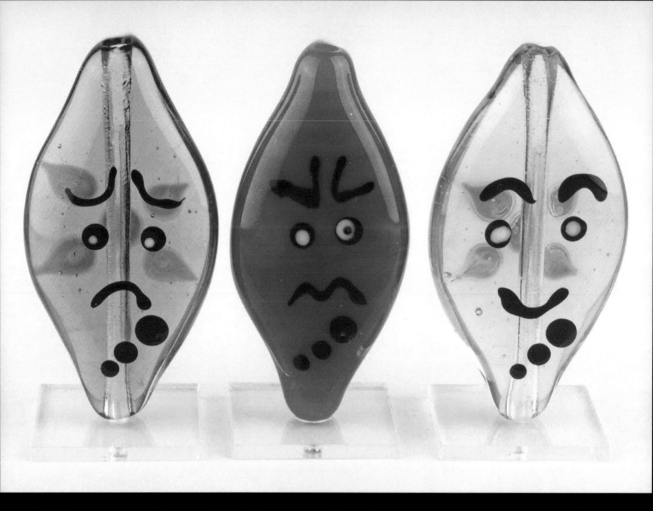

TITLE: SIXTEEN YEARS OF STRUGGLE

"Making glass beads has been instrumental in my recovery. I've met many wonderful people and gone many interesting places in the course of following this passion. The opportunity to do something creative that I am good at has allowed me to shift my focus from being a broken, sick person to a person who creates and is able to bring some joy into the world. Glass bead making has allowed me to live again.

"This piece shows some of the emotions I have gone through on my journey through mental illness. Thankfully I have reached the point now where I am content."

eventually, diagnosed with schizophrenia.

"I thought, 'Well, I guess I didn't escape it after all," Snuttjer recalls. "And I felt, 'You know, I'm screwed.' You get really depressed."

Over the next several years the delusional voices she experienced and her hold on reality waned and escalated, sometimes prompted by going off the anti-psychotic medications she'd been prescribed at the misguided urging of her mother, a natural foods advocate who thought a vegan diet might be the answer to recovery.

In 2002, severely depressed, she moved back in with her mother, who had taken a job in Alabama, and took a position as a quality control clerk in a potato chip factory. Given her abiding difficulty in staying away from the salty snacks — a side effect of almost all anti-psychotic medications is weight gain — this might seem humorous. In fact, it was anything but.

"That was my darkest moment," she recalls. "I lost all hope of ever having a life again. I was just desolate."

Snuttjer had always been fascinated by glass blowers and glass as an art medium. Before her health deteriorated, she'd taken an introductory glass beadmaking class, taught in the kitchen of a work colleague. Remembering her pleasure in this, in 2004, she took the refund from her tax return and bought a beginner's torch, one barely hot enough to melt glass, and started experimenting.

Realizing her daughter needed more structure and purpose to her life, Snuttjer's mother eventually set up a glass studio for her, with more professional equipment.

For four years, from 2008 to 2012, Snuttjer spent approximately 20 hours a week creating beads. She took classes and experimented with new techniques. She joined the Southern Flames, a chapter of the International Society of Glass Beadmakers, where she found social acceptance, encouragement and praise. And gradually, she began to dig herself out of a dark hole.

"I had been doing nothing for eight years," she says. "It was a miserable existence. With the beads, I began to realize I wasn't just a worthless lump of flesh. I had something I enjoyed and I was good at."

But a psychotic break is "an electrical and chemical storm in your brain and it takes a long time to heal," Snuttjer admits. In 2013 she had another break and totaled her car, a Honda Insight, after driving over a fire hydrant. She jokes about it now, noting how the first thing to disappear when delusions strike is her "insight" into her illness.

For a long time, Snuttjer didn't reveal her condition to anyone. But she is an unfailingly honest person and when people asked why she was on disability, she couldn't bring herself to lie. She would tell people she had a "brain disorder," but no one seemed to understand what she meant. Eventually, she looked at it as an opportunity to educate.

"At first I didn't want to tell people my diagnosis because I felt they would feel as horrible about me as I felt about myself," she says. "But then I realized, if I can't accept myself, no one else will be able to accept me."

For the past year, since she and her mother moved to Sarasota — and especially since meeting her boyfriend, who has dealt with his own mental issues, on OK Cupid last April — her life has been stable and "more wonderful than I could have imagined." (Neither knew of the others' mental health condition when they first met; both were relieved when it came out.)

This summer the two started a web comic called "Our Mad Life" that explores in a comedic way the challenges of dealing with a mental health condition. He does the drawing, Snuttjer, who has a sense of humor that is both quirky and wise, writes and colors the strip.

"I was so long without even any friends," she says. "How I feel now is every good feeling you could ever feel. It's not that he gives me hope — I had hope — but he gives me a vehicle to pursue success. We balance each other, we help each other, we support and motivate each other. There's a reason to live because you have this person. In a lot of ways, it's what I've been waiting for all my life."

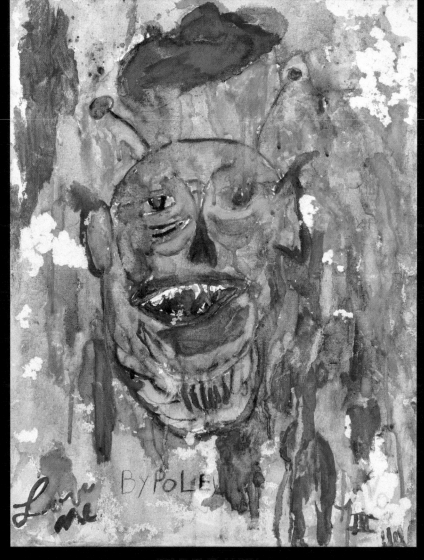

TITLE: THE ALIEN

"My picture? I thought of a flying saucer and a Martian taken up. It represents me as a Martian because you're made to feel like a monster when you're bipolar. We all feel that might makes right. In this world, there are people who have to feel mighty to feel right. But might does not make right. We feel unloved, unwanted, unassured. I think this is what I look like by having bipolar."

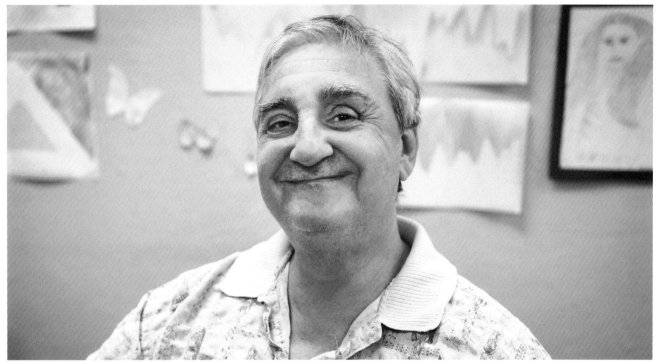

ANGELO OLIVERI

Growing up in Brooklyn, Angelo Olivero dreamed of becoming a cartoonist for Walt Disney, a man whose name he speaks with the reverence of a prayer.

"He was thinking about creating a world with all the joy he could bring to people, and he did it," says Olivero, 65, seated in a room of Anchor House, the Mental Health Community Center's drop-in facility in North Port, surrounded by walls filled with pictures created by the center's members. "A lot of times, I wish the real world was like Disney."

But long before his bipolar disorder was diagnosed, Olivero learned that reality was not much like "the happiest place on earth." An older brother died in childbirth; an older sister with developmental disabilities who became pregnant in her teens was sent to the state mental hospital, where she died in her 20s. His father, a truck driver who had emphysema and COPD, the result of having taken up smoking unfiltered cigarettes after dropping out of school at 9, died when Olivero was a teen.

His mother, a nurse's aide, adopted her grandchild, Brenda — the aunt whom Olivero still refers to as his sister — and struggled to keep the family afloat. Their situation was dire. They lived in a basement apartment "next to the laundry room," the only white family among Puerto Ricans and African-Americans. Gangs ruled the neighborhood and the police, says Olivero "were as corrupt as the people they tried to beat." Food was hard to come by.

"Let me put it this way," says Olivero, who has a ruddy, plump face, a childlike smile and the ability to quote verbatim Shakespeare's "To Be or Not to Be" speech without a prompt. "We had powdered eggs from cardboard chickens. My father would give me a finger of brandy to face the cold in the winter."

Olivero turned to art as an outlet, drawing during classes on the heel of his shoe as he sat with one leg crossed on his other thigh. In 11th grade, he dropped out of school and entered an all-boys technical program, where he learned clock and watch repair, something that interested him a lot less than pretty girls.

After seeing a commercial for Disney cartoonists, he decided, "I wanted to come to Disney and meet someone."

But learning disabilities, his escalating mental health challenges and a "learned helplessness," as Brenda Olivero calls it, resulted in a series of job failures as a security guard, dishwasher and theater usher. After his father's death, Brenda moved the remaining family with her to Pennsylvania, where Olivero mostly stayed at home, his anxiety eventually turning into mania, the mania into psychosis. Though he was diagnosed with severe depression -- "an umbrella word that didn't touch what he was dealing with" says Brenda Olivero -- his mother never filed for government assistance, something that made it even more difficult to obtain disability benefits after they all moved to Florida in 1997.

After the move, Olivero continued to spiral downward. Brenda, overseeing his care while trying to provide for her own five children, struggled to find a living situation for her uncle that would work out. Several times, when his mania became unmanageable, she was forced to invoke the state Baker Act and have him hospitalized for involuntary evaluation.

After his mother's death in 2008, Olivero moved to a group home. But that ended disastrously too, after another resident stabbed him repeatedly, nearly killing him. Hospitalized in long-term intensive care, Olivero underwent heart surgery and lost a kidney and his spleen.

Despite a remarkable full recovery, within a few years he was hospitalized again, this time with doctors advocating for his admittance to a state hospital. Having seen the treatment of her own mother, who died in a similar institution in New York, Brenda Olivero refused, taking him for a time into her own home until she found the retirement center where he now lives.

Throughout, Olivero says he was sustained by the only thing that has ever given him an outlet — art and music. Brenda Olivero has kept notebooks that are stuffed with his drawings and paintings, many of them eerie, fascinating, brilliant — and often, irrevocably sad. Through the years, he would give them to her and her children as presents on birthdays and holidays.

"That's how he's coped his whole life," Brenda Olivero says. "He would draw the feelings he couldn't speak. His artwork contains everything that's inside him."

As for Olivero, he longed for a purpose, a life of his own and a woman to love. Brenda Olivero says he always wanted the beautiful, unobtainable girls and that "he would never settle, so he never had anybody."

"I've only ever known unrequited love," he admits, "and that's a rough kind of love."

After they came south, Olivero finally got to go to Disney World, that mecca he'd so often dreamed about. He was awed by the animatronics; he was enticed by the thought of living in the Disney master-planned community outside Orlando called Celebration. But he had realized by then that "if you have any kind of bipolar, they won't accept you." Even as he says "everybody needs somewhere they can have a job and be happy doing it," you can tell he doesn't have much hope of ever having one himself.

"Are you kiddin' me?" he says, his Brooklyn roots still influencing every syllable. "Every day I wanted to be somebody. I didn't feel I was anything. And when you feel like you're nothing, you get beaten down. We get locked into what we say every day. We become prisoners of our own minds."

SUSAN BRODSKY

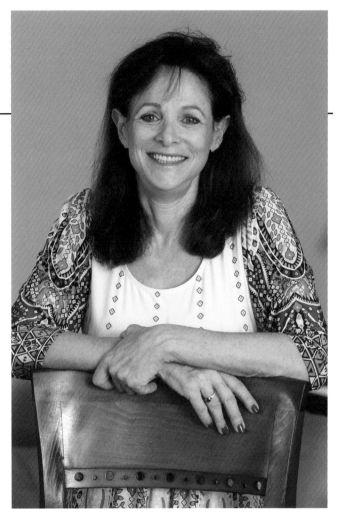

Photo by Dan Wagner

Suzan Brodsky's resume is a record of wide-ranging ability and accomplishment. She has been a merchandise planner for TJ Maxx, a site selector for McDonald's and Shell Oil, a lease and zoning negotiator for developers and — after a marked but intentional career change — a middle school language arts teacher. She raised a son, now 23, who has begun his own successful career in television news and she is now, in semi-retirement, tutoring children, teaching Sunday school and anticipating her remarriage next year.

In short, her life looks like the life of any person with talent, intelligence and ambition. Which is why it made Brodsky so angry that, for decades, she felt forced to hide the fact she has also contended with bipolar disorder.

"I am so not a tragic figure," says Brodsky, who moved to Florida from her native Massachusetts a dozen years ago. "What happened to me was horrible, but it was not a tragedy. I felt successful. And I felt angry I had to keep this secret. I thought it was an injustice to all people with mental illness that they have to walk around in the shadows."

But for nearly 40 years, that's exactly what Brodsky did.

Her "basic childhood" in a Boston suburb — walking home from public school for lunch, studying piano, singing in the chorus — did not presage any problems. But two years into college, plagued by depression and finding it hard to keep up with assignments, classes and friends, she withdrew and returned home. Though her mother now says she recognized her daughter's condition, back then, "nothing was ever discussed" Brodsky says, and she did not see a psychiatrist.

Looking for a change, Brodsky moved to New York City and earned an associate's degree at the Fashion Institute of Technology, then returned to Massachusetts and a job with TJ Maxx, with aspirations of becoming a buyer for the discount clothing chain. Her first full-blown episode of mania changed all that. She was let go from her job, evicted from her apartment and taken to court by a roommate who accused her of stealing. Hospitalized, she was given a diagnosis of what, at the time, was called "classic manic depression."

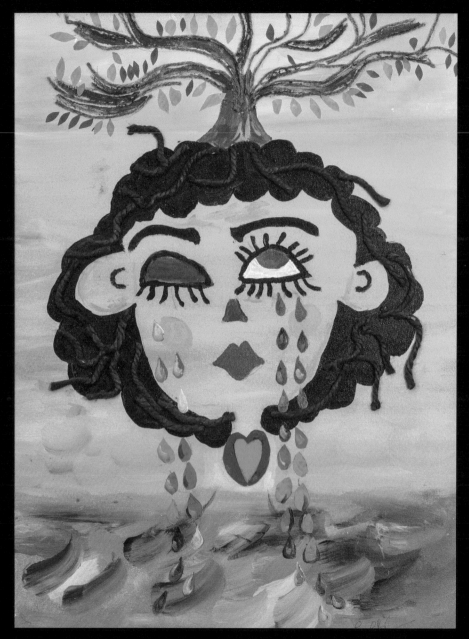

TITLE: CRY ME A RIVER

"Just get back up when you're down. Everything happens for a reason. Be patient. Good will come your way."

"I remember hearing that and thinking 'That doesn't sound good,'" Brodsky recalls. "But I didn't get it. I knew what I was doing wasn't logical, but I was thinking it was temporary. It never occurred to me this was a chronic, long-term situation."

At that time, and in a place where inpatient psychiatric services were more readily available than they are today, Brodsky spent the next two months at mental health "camp," as she jokingly calls it, meeting "the first of a long line of friends with mental illness."

"You may not keep them, but you become closer to them than anyone else because they understand," she says of those who have shared her struggles. "You bond."

Following a brief period of stability, an intense depression caused Brodsky to voluntarily enter the psychiatric unit at Tufts University. Surrounded by patients whose conditions were far more severe than her own, she remained for nine months, on a "step-down" basis — gradually released on weekends, then nights, then entirely. Her memories of the experience are mixed; she bridled at doctors who continually advised her to "lower her expectations," but recognized how the structured, long-term program was essential to her recovery.

For the next 20 years, Brodsky remained symptom-free. She married, had her son and managed the typical stresses of a working mother. Eventually, realizing that her marriage would not survive, she went back to school on nights and weekends for two years. Her divorce and her degree came simultaneously and, with her background in site selection, she chose Sarasota for a fresh start. There were some difficult transitions — for one, trying to retain her psychiatrist of 20 years via the telephone— but Brodsky loved the warm weather and her new job as a middle school language arts teacher.

Then, a "perfect storm" of stress — the recession, the failure of an ill-advised second marriage, some behavioral issues with her son and a transfer to teaching math, a subject she abhors — upset the balance she'd worked so hard to maintain. With her doctor miles away, she spiraled into the most severe depression of her life. Several hospitalizations and the near loss of her home forced a withdrawal from teaching and eventually, the realization that she needed to file for disability benefits. The disappointment was crushing. But after several mismatches, she found a doctor who revived her hope. 'I'll never give up on you,'" he told her, and she believed him. That, and the support of her now fiancé, David, kept her afloat.

Gradually, Brodsky began to build another new life. Six years ago, she took a peer-to-peer class from the local NAMI (National Alliance on Mental Illness) chapter which "opened another window of understanding." But her secret remained closely held.

"I was completed isolated with my illness," Brodsky says. "I lived with the idea that I was highly stigmatized and I was afraid of being judged."

Finally, she realized it was time to break her silence. She took a class to become a peer educator for NAMI, and accepted an invitation to become a member of its rejuvenated board. Not long ago, she spoke on a mental health panel before a packed auditorium, confidently sharing her story and bringing the audience to tears and applause.

"I'm such an average, ordinary citizen in society," Brodsky says, deflecting praise. "That makes me a good person to talk about this. I came out because I actually would like to help people not have to go through everything I went through. It's not that everything will be fixed, but there are so many things I've learned you can do to make your life better.

"My life is not a tragedy, it looks very normal and I've gotten good at maintaining all the time. Actually, sometimes I think I'm happier than people who don't have a mental illness."

LORI WIEST

At the Wilmington, Delaware middle school where Lori Wiest was a young student, everyone had a combination lock on their locker. But not everyone felt compelled, as Wiest did, to methodically turn the dial the same number of revolutions every time, or to always and precisely end on zero.

By the time she got to high school, her numerical compulsion had escalated, obliging Wiest to count to 16 over and over, endlessly touching and arranging things as she named each number. Her anxiety over being "discovered" by others paled beside her anxiety over what might happen if she didn't follow through.

"When I was 15 or 16, the counting started and for the better part of 24 years, it continued," says Wiest, now a rosy-cheeked 47-year old with gray in her curly bobbed hair. "It's certainly not anything you would choose to have. When people saw my habits, it was mortifying. But I could not stop."

Sitting in the comfortable central gathering room of Prospect House, the Mental Health Community Center's Sarasota drop-in facility, Wiest shows no sign of the obsessive compulsive disorder she has dealt with most her life, nor of the mania and depression that surfaced in her early twenties. But in fact, even before her own symptoms surfaced, she was already familiar with the painful repercussions of a mental health challenge.

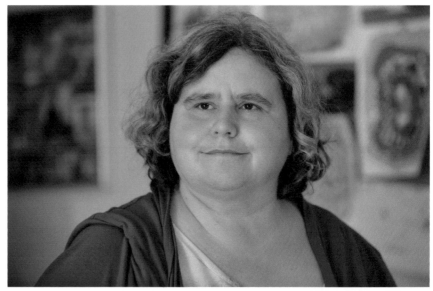

Photo by Dan Wagner

The daughter of a homemaker and a father who headed an organization then known as the Delaware Association for Retarded Citizens, Wiest was a "good girl" and a bright student, albeit shy and somewhat socially inept. But from an early age, she felt weighed down by "the family secret" – her mentally unstable older brother, who had OCD and a mood disorder, and who used to terrorize Wiest and her mother every afternoon before her father returned from work.

"He would trap me and my mom in the kitchen and yell at us, red-faced, eyes popping out of his head," she recalls. "I would plead with my Dad to do something, but he'd say, 'I can't, because I'm afraid your Mom would leave me.'"

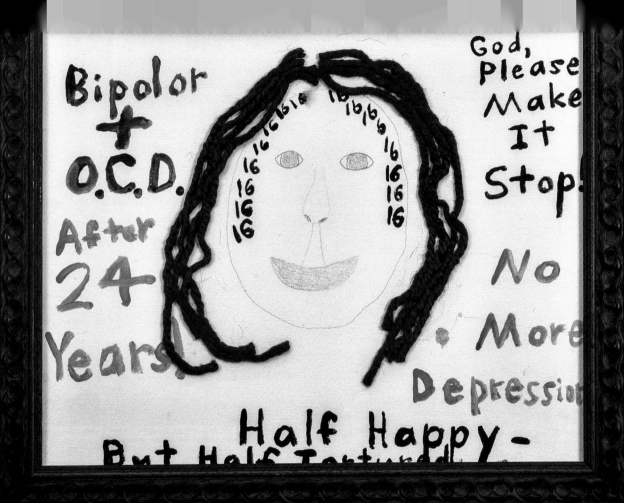

TITLE: GOD PLEASE MAKE IT STOP

This painting is about what goes on inside my head on a daily basis and how my life changed when my constant depression went away four years ago."

Consequently, when she graduated from high school in 1987 Wiest accepted an honors scholarship to Eckerd College in St. Petersburg, Florida with alacrity. But despite seeing a therapist in Sarasota, where her parents had resettled, by the end of her freshman year she was on academic probation after struggling with a learning disability in math and falling into a deep depression.

"I remember seriously thinking of jumping into a retention pond at school after I failed that test," Wiest recalls.

Her depression, and subsequent episodes of mania, landed her in the hospital more than once and forced her to drop out of school. She moved in with her parents in Sarasota and transferred to Manatee Community College, splitting her time between sporadic classes and working low-level jobs that often ended in failure.

After earning an associates degree, despite her ongoing depression she enrolled at the University of South Florida in Tampa and did relatively well. But, shortly before completing a degree in French, a suicidal episode derailed her progress again. Deeply discouraged, she returned to her parents' home and accepted a minimum-wage job assisting residents at a group home for individuals with developmental and physical disabilities.

There, she flourished and met a woman who would become her best friend and is now her current roommate. Wiest "loved helping people," but after five years, the home lost its license and she lost her direction. Since then, she has held several part time jobs in home healthcare, but has relied mostly on disability payments to get by.

For support, she began attending the Sarasota Center of Light, a metaphysical church with a different approach to spirituality than either her Christian upbringing or her adult years as an agnostic. The center, Wiest says, which draws its teachings from many religions, sees Jesus Christ as a great healer, rather than someone meant to absolve sins. Part of the congregants practice is to make contact with "spiritual guides" who can deliver messages of direction.

Five years ago, Wiest received two such messages. The first told her that her depression would end. The next, not long thereafter, was simply a phrase: "Ye shall have joy."

"'That's not going to happen,'" Wiest remembers saying to herself. "I thought it was a figment of my imagination. But to my surprise, Easter of 2012, after being diagnosed as mixed bipolar, I was relieved of my depression."

Wiest is a bit reticent to share her transformation. She's well aware of the reputation of delusional religiosity many assume comes with a mental illness diagnosis. Yet she also knows the authenticity of her own experience.

"I'm not a 'religious nut,'" she insists. "This is not about 'You have to believe.' I'm not like that. I was someone who didn't believe things unless they were under a microscope. But after years of adhering to my meds and trying all kinds of anti-depression aids, they did nothing for me. I can understand people not believing me, but in fact, it totally happened that way. And I thank God every day for the healing I've had."

Since then, Wiest has experienced only minor depressive episodes; she's become a member at Prospect House, where she is training to become a peer counselor. She still wrestles with her OCD compulsions, though she's learned some coping mechanisms that help her deal with it – meditation, visiting the healing garden at church, going for a walk in Red Bug Slough. Her perspective on the affliction has also changed.

"Mental illness is like your brain's not a part of you, it's your own worst enemy," she says. "My OCD can be severe, but thankfully, I'm able to function. And I think maybe I have that to keep me in touch with human suffering and the need to help others. That makes more sense to me than to think you're being punished for your sins."

LEONARD HOFFMAN

When he was at his absolute nadir — deeply depressed, filled with self-recrimination and facing the prospect of rebuilding every aspect of his life after 16 months in prison — it was art that saved Lenny Hoffman. It was art that gave him the only hope he could hang on to.

"I'd go home and paint," says the 37-year-old Florida native. "In that moment I could be an artist — not an ex-offender, not someone with a mental health disease, but someone who was doing something creative and good. Someone who was not a loser."

More than three years later, Hoffman is still reconstructing a life dismantled by the onset of a mental health disorder. And he is still painting. The dining room he has turned into a small art studio is stacked with canvases, mostly portraits of figures with haunting or haunted eyes, a window into his own journey through and out of psychosis.

Hoffman's creative talents surfaced early when, in kindergarten, he won a "top banana" award for being the best artist in his class. Give him a pen or pencil back then and he'd be doodling all over his school work.

But the depression that has plagued him most of his life surfaced early too. His temper was volatile; his frustrations easily led to emotional overload, and from there to screaming, hitting, yelling. By the time he was in middle school he'd already considered suicide, deterred only by his fear of what it might do to his mother.

"I developed this idea in my head that I was a monster," he says, "that I was bad deep down and in order not to be, I had to fight to get control."

His first formal art class, in high school, exposed him to the world of Surrealism and Expressionism; he was inexorably drawn to "the stuff that was 'out there.' " But a teacher

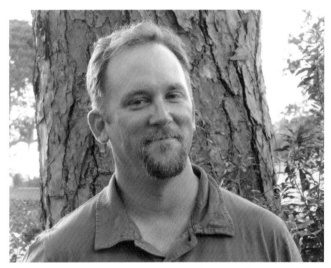

Photo by Carrie Seidman

who convinced him that he would become "the school decorator" if he pursued a teaching career made him temporarily put art on a back burner.

Instead he got a degree at Florida State University with the idea of becoming a librarian. Disenchanted after several years of working in the college library, he returned to school to pursue a master's degree in humanities, with the intent to teach at the high school level.

Despite his "fairly constant" depression, and driven by an idealistic idea of what love could do and mean, he married his college girlfriend at 20. Five years later, after the birth of his son, the marriage began to crumble. In the summer of 2011, he and his wife separated and Hoffman went from working three jobs — teaching history at a Jacksonville high school, working in his father-in-law's painting business and instructing a night class — to none.

His marijuana intake escalated in line with his depression, his thinking became disorganized and detached from reality. In what he now refers to as his "crazy period," he had his first full blown episode of mania. At the time, it seemed magical.

"It was a gorgeous, beautiful feeling, as if the whole energy of the universe was flowing into my body," he recalls. "This lifelong depression flipped on its head and everything was wonderful. But after that, everything was different."

He realized he was behaving abnormally, but even after looking up the symptoms for schizophrenia and recognizing most of them, he didn't see his behavior as a disease, or even a problem. It seemed to be the problem of those less enlightened than himself.

"I thought I was weird, but not sick," Hoffman says. "I thought people just didn't understand me. I was just being an artist."

That was July. At the end of August he went back to his teaching job. Within weeks his behavior got him removed from the classroom.

Not long thereafter he was arrested, jailed, and placed in the self-harm unit known as the "baloney hole" for its solitary confinement and daily meal fare of hot dogs.

Evaluated and diagnosed with schizoaffective disorder, bipolar type, Hoffman was released to a behavioral hospital, where treatment was short term and woefully inadequate. What followed was several months of cycling in and out of hospitals, jobs and mental states.

On March 21, 2012, he was arrested again, this time for a second-degree felony. Declared legally sane and facing a maximum 30-year sentence, he pled guilty and accepted an offer of a year in prison and eight years of probation.

"The big thing for me was to say I did it, to take responsibility and begin the process to make sure it never happened again," he says.

He didn't fit in with the rest of the prison population — "I made a mistake and didn't want to do it again. Most people there are going to go right back" — but he endured, drawing portraits to trade to fellow inmates for dinner or dessert and mailing drawings to his young son. His father, who called daily, asked his son, "What are you willing to do to rebuild your life?" Hoffman replied: "Anything I have to."

"I had no pride," he says. "I knew I was starting from the bottom."

Released after 16 months in jail and prison, Hoffman moved in with his father in Sarasota. Step by step, he began the rebuilding process: Working with a psychologist. Attending church and the Buddhist temple. Medication and meditation. Day jobs, from laying sod in the hot summer sun to wrestling fish to harvest caviar for Mote Marine. Eventually, he took a part-time position at the landfill in Nokomis; two years ago he was promoted to full time and last year to assistant manager.

Daily phone calls to his son, now 10, in Jacksonville and monthly trips to see him remain a major motivator.

"I want to be there for him," says Hoffman, whose gratitude to his own father for helping him during his crisis is tangible. "For all I know, he may have the gene for schizoaffective himself. Who knows what or when his crisis will be? My big goal is to be ready for that moment."

His creative impulses are channeled into "Our Mad Life," a mental health web comic he started last year with his girlfriend, who shares his diagnosis, and infrequent commissions for pet portraits. Art remains a steadfast passion and life preserver.

"The biggest thing is it provides a solid sense of identity," Hoffman says. "When I do my art, I don't feel I have a disease or a history.

"I wish I could say to people with mental health issues — your life is not over. You can still be creative and productive. You may not have a life that looks like everyone else's life, but there is still a life for you."

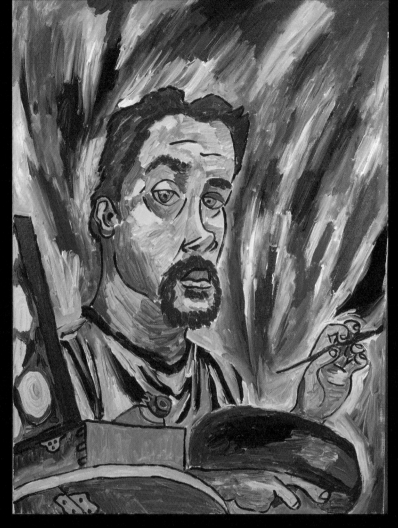

TITLE: THE PAINTER

"Art has been with me for a long time. In my recovery, art has helped to give me an identity above my sickness, my criminal history and my past. An artist is someone who creates something. And that is important to me. In my art I try to express the emotions of the subject and when it is a self-portrait, I want to be brutally honest with how I look, how I feel and be aesthetically experimental. I want this piece to express my voyage through madness, in the dark periods to where I am now, which is that I've found a place for myself and some measurement of happiness. I want to say that it is possible for everyone."

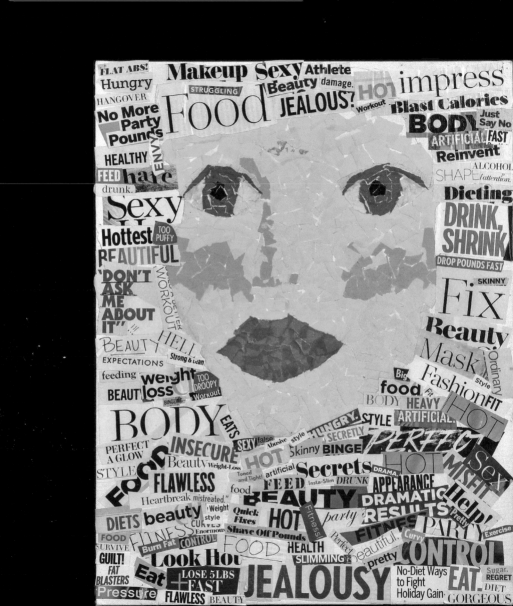

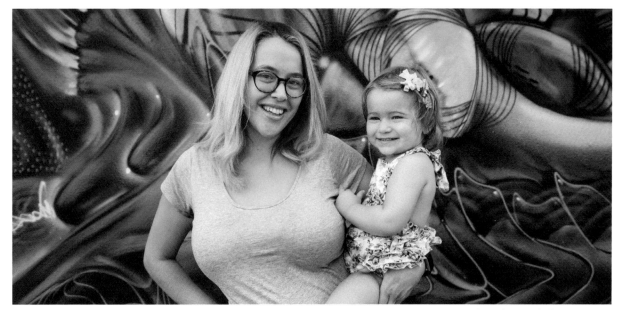

Photo by Rachel S. O'Hara

FLORENCE SCHMITT

Florence Schmitt is a testament to the fact that even the financially privileged, intellectually gifted and physically attractive are not immune to mental health challenges. Blonde, beautiful, smart, articulate and seemingly superbly confident, it's easy to assume she's had the life of someone to whom everything has come easily.

Yet the UK native says the roots of her eating disorder and alcohol addiction can be traced all the way back to her earliest years, as a 3- or 4-year-old at an exclusive Montessori school.

"I remember my whole life having this feeling that I'm not good enough and needing other people's approval," says Schmitt, 30, balancing her squirmy 2-year-old daughter, Lila Rose, on her lap. "There was a little girl at school and every day I would ask her, 'Can I be your friend today?' And I based all my feelings on how she responded. I was set up from then on to rely on other people's opinions for my self-worth."

Her decade at a private boarding school, from 8 to 18, precipitated the eating disorder that would rule her life for years. Every quarter, the head matron would bring out a scale and measuring tape and line the female students up, calling out their weight and height for all to hear.

"I remember the fear and dread that caused as I got closer and closer to the front of the line," recalls Schmitt. "I remember thinking, 'It would be better if I were thinner. It would be better if I didn't eat this food.'"

Thus began a frustrating cycle of abstaining, binging, "bizarre diets" and purging; sometimes Schmitt would wander the supermarket aisles in a stupor, looking at everything she "shouldn't" eat and walking out with a jar of pickles. At the same time there were other adolescent struggles — a traumatic sexual experience at 13, peer rejection, an anxiety-producing need to hide her illness and appear "normal" to the outside world.

Though her brother discovered her eating disorder when she was 15 and her parents sent her to counseling, none of the help she received was long or intensive enough to make her abandon the one thing that had offered to be her "best friend" — food. Eventually, binge drinking would be added to the mix.

"It's easy to say that an eating disorder is about wanting to lose weight, and undoubtedly, the obsession with food is a huge part," she says. "But the truth is, an eating disorder is really like many self-harm actions. It's a coping mechanism."

After graduation, Schmitt moved to London, her heart set on an acting career. But the pressures of school and the performance world put another set of expectations on her appearance. Her well-meaning parents, who thought their daughter might be happy if only they could help her become thinner, just exacerbated the problem. After five years at two universities, she dropped out, her deteriorating physical condition threatening her very existence.

"My sense of failure was so intense, I couldn't go on," she remembers. "I was so trapped in the addiction and the food, I felt like a prisoner. I didn't want to live, but I didn't want to die."

Finally, the father of a friend, a psychiatrist specializing in addiction, recommended inpatient treatment. So beleaguered was Schmitt, she acquiesced without a fight.

"There was not one ounce of resistance left in me," she says. "The relief I felt was extraordinary. It was the first time I felt hope."

Thanks to her father's finances, she entered a top tier rehab program in South Africa. She willingly gave up alcohol immediately, but clung tenaciously to her food addiction. Finally, after a panic attack so severe that she "wanted to throw petrol on myself," she succumbed to intensive therapy in an eating disorder clinic. To those who claim an eating disorder is not a mental illness, Schmitt has strong words.

"It goes entirely against all human instinct to deny yourself food," she says. "It is the archetype of a mental illness. An obsession with being thin isn't necessarily a mental illness. But where it can take you to is."

Convinced her therapist had a mission to "make me as big as a house," she nevertheless signed on for five months of a disciplined reconstruction of her diet. At the same time, through therapy, she stopped defining herself as a victim of her circumstances and started holding herself accountable.

"That's when the challenge comes," she says. "You can find radical recovery in honesty or you can say, it's not my fault. Yes, you are a victim in some ways, but is it serving you? No, it was damaging me terribly. One of the best moments in my recovery was letting go of the drama."

Out of rehab, she returned to England and, thanks again to her father's support, she immersed herself in making beaded jewelry. Soon, another friend from rehab joined her, and then another. One day, one of the women said: "If we sold this jewelry, we could be a social enterprise." Schmitt jumped on the idea and set up a charity called Sweet Cavanaugh (her mother's maiden name) under the umbrella of a nonprofit called Free Me; all the women who participated were recovering from eating disorders and addictions.

The other positive thing that happened on her return to London was the reappearance of Steven, now her husband of three years. She'd met him her very first day in rehab and, sensing a strong attraction, thought, "Oh shit, I've come all this way to get away from this!" When she moved to another center, they didn't speak for eight months, though they did write letters; once in London together, they were inseparable, "a modern day love story," as Schmitt calls it.

They were married in February of 2014 and Lila Rose made her debut not long thereafter. Last August, they moved to Sarasota, where Steven was born. Now as they await their second child, Schmitt is developing plans for another social enterprise, one that focuses on employing those who are homeless.

"Mental illness doesn't care about your background, your race, your gender, or your status," she says. "With money, it can just take longer to get to the bottom."

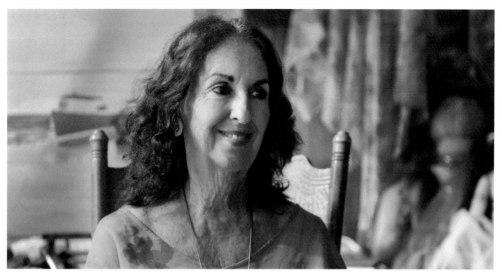

Photo by Dan Wagner

SHEILA CAREY

Raised Catholic by an Irish father and Portuguese mother, Sheila Carey was a virgin on the verge of completing an art degree in Chicago when she met a German man with red hair and blue eyes who captured her heart. Within a year, she was pregnant and her red-haired flame had nixed plans for a wedding. Carey returned to her parents' home in Indiana for Christmas to "drop the bomb."

"It's 1970, I'm 21, unemployed, unmarried," says Carey, seated in the colorful lanai of her Englewood home that also serves as an art studio. "What do you do if you're an Irish Catholic girl? I went to Catholic Charities."

Seven weeks prematurely, and after 21 hours of hard labor, she gave birth to the son she named, in her mind, Seth, and immediately gave him up for adoption.

"I got to see him born but they never let me hold him," says Carey, who retired last year from a career in nursing. "And I'm glad they didn't because if they had, I never could have signed the papers."

She spent the next three months on a lounge chair, exhibiting the opposite extreme of the "hyperactive" label she'd been handed as a young child, a condition she now identifies as the likely precursor to her eventual diagnosis. Her depression was deep and unrelenting but, at the time, considered by doctors to be situational.

Slowly she "came back to life," but her moods continued to alternate between a black hole that always seemed to worsen between Mother's Day in May and her son's birth date in June, and a manic euphoria that "always found something to laugh about." At 24, she was finally properly diagnosed with bipolar disorder.

A brief marriage catalyzed by her hope to conceive another child ended amicably after she realized he "wasn't capable of being a father" and eventually led Carey to yet another union, with a former schoolmate to whom she applied for a job. She didn't get the job but, desperately hoping to become pregnant again, found a new husband.

The couple moved to Hawaii where they had a house overlooking the seas and four dogs. As Carey slid into another devastating depression despite clear signs of her lassitude, she, and everyone around her, remained in

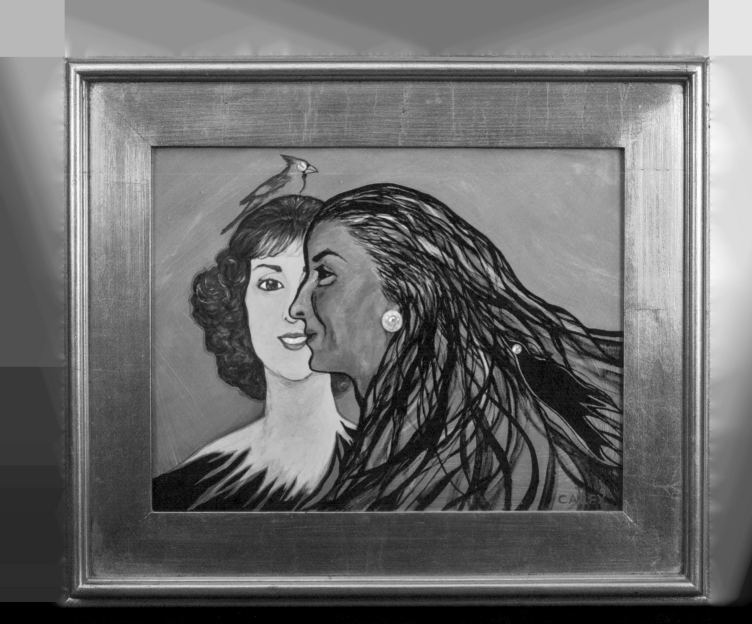

UNTITLED

"My real challenge is day to day living; many has been the time that I loathe just getting out of bed and frequently have remained in bed most of the day. However, I have two dogs who require walking, so they are a great antidote to depression. Attending to the needs of others has often been better than anything else for my disorder."

denial. Then, at 33, she swallowed 120 pills and had a "near death" experience.

"To be in that dark spot where you don't want to live because you're in such psychological pain ... I went down the tunnel," she says. "I was declared D.O.A. And then all of a sudden, something brought me back. I woke up with a tube down my throat and an IV and I thought, 'Damn it, I can't even kill myself right.'"

Days after she was released from the hospital, on a church retreat, a woman asked her to consider why she might have "come back."

"The only thing I could think of was that I needed to find my son," says Carey.

But at the time, she was still fixated on becoming a mother. Her marriage broke up after she started an affair with a younger man, with whom she moved to Dallas. The mood swings continued, but now it was the manias that were predominant. They lead to wild and expensive, shopping sprees that threatened her financial stability. Despite a string of doctors, medications, therapy and treatments "I was still making the same mistakes," Carey says.

Within three months of finishing the requirements to obtain her LPN license at a south Texas hospital, she ended up as a patient at the very place where she'd been training.

"My doctor made me go down to meals with all the crazies and my classmates staring across from me," she recalls. "I was a leper."

A year later, "the sun came out" and Carey was able to finish her degree. She accepted a position as a labor and delivery nurse and, after yet another divorce, moved to Dallas to be closer to her late sister and to complete the requirements to become an RN.

"Gratefully, there were no questions about my mental fitness on any of my nursing applications," she says. "And, for many years, medication, meditation and therapy sustained me."

Still, Carey could not let go of the heartache she'd harbored for 25 years. She signed up for a birth parent registry she'd read about on Dear Abby, but was informed her son had not initiated a similar search. The registry suggested she obtain her hospital records and contact Catholic Charities and when Carey did so, she got some startling news: "Your son has been looking for you for seven years, ever since he turned 18."

In 1995 she heard his voice on the phone for the first time; months later, they were reunited in Dallas.

"I was higher than a kite," says Carey, laughing. "But being a nurse, I was very careful to stay on my meds and do therapy."

Not long thereafter, she moved to Florida, where her mother was living, and again took up painting, a therapeutic art she had abandoned for nearly two decades. Her son — whose given name, Jeff, is eerily similar to the one she would have chosen herself — has been a regular visitor and last summer they rented a log cabin for two weeks together, near the Chattanooga, Tennessee home Jeff shares with his wife.

The reunion with her son and the move to Florida initiated "a whole new era," says Carey, whose black depressions ceased and whose manias now consist of mostly of shopping binges at the local thrift store, where the resulting financial damage is minimal.

"The best part of me is the social," says Carey, who offers a visitor freshly-baked banana bread and a greeting card printed with a scene from the artwork she has shown at the Art of Ireland Gallery on Palm Avenue in Sarasota. "I long ago decided the No. 1 quality is kindness and it's the quality I most want to possess."

The most recent step in her recovery has been to share the secrets she hid for decades — the existence of her son and her bipolar diagnosis — with others beyond her immediate family.

"As Carrie Fisher said, 'It's our secrets that make us sicker,'" she says. "I want to share how healthy one can be just by paying attention to what you need. I'll never not have bipolar, but now I know you can recover. I'm in a very happy place in my life. I've come full circle."

NEVEAH THOMPSON

Like any mother, Idalia Rivera was distraught when her youngest daughter, Nevaeh Thompson, came home from school every day crying, feeling like an outcast because her fellow students either made fun of her or ignored her. A visit to the doctor led to a diagnosis of Attention Deficit Hyperactivity Disorder (ADHD); at just 4 years old, Thompson was put on a low dose of medication.

"The doctor was hesitant because she was so young," Rivera says. "But because she wasn't doing well at school, he wanted to try a little."

The medication did, in fact, help slow down Thompson's racing mind and calm her fidgety limbs. But it only exacerbated the taunting by her peers and increased her feelings of exclusion.

"Kids would say, 'Did you take your meds today?'" says Thompson, her lean, wiry frame topped by two pom-pom pigtails. "Not in a nice way, like they were concerned, but in a bad way. And if I said, 'No,' they'd smile and say, 'Ohhh, *that's* why.'"

Thompson couldn't understand why, when her teacher shared with the class that she often also got "off task" and needed medication to focus, there seemed to be a real double standard.

"The kids think the teacher is so awesome, even though she takes pills," Thompson says. "Why is it different with me?"

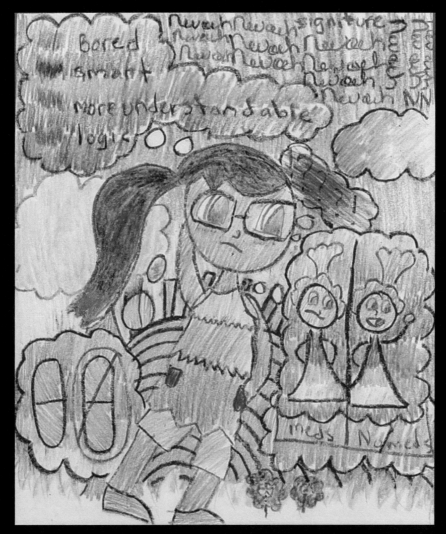

TITLED: HOW MY MEDS AFFECT MY LIFE

"My medicine affects part of my life, especially the mornings. Every day I wake up feeling very energetic. (That's probably why I wake up first.) Usually my brother or sister tells me to take my medicine and it makes me feel belittled. After I take my medicine, it makes people think I'm no fun, which makes me feel kind of sad. So those are two of the main reasons I don't like taking meds.

"My picture is about me and how I feel when I take my medicine. How and why my hair is colored is because it shows how I feel and express myself. Like, for example, I'm calmer when I take my meds."

Even at home when her older sisters, one of whom also has ADHD, and brother would ask, 'Nevaeh, did you take your meds? Go take your meds!' Thompson would explode with resentment, saying, "Mom's supposed to tell me that, not you!"

All of this conspired to make Thompson not want to take her medication at all. And there was another reason, too, a personal one she felt no one else could understand without living in her body.

"When I'm off my meds, I'm really energetic and fast," Thompson says. "When I take my meds, I feel more calm, but I don't feel like my real self. It makes me feel like….what's that word you said, Mom? Belittled? I feel less of myself. And I don't want to be someone else. I want to be me."

Empathizing with her daughter's frustration, Riviera sometimes let Thompson have a day off from medications on the weekends, when sitting still and staying focused for school activities wasn't required. Sometimes that worked; sometimes it didn't. But when things would get a little out of control, Rivera discovered something else that helped.

"She would be like climbing the walls in the house and I'd say, 'Nene – that's her nickname – Nene, why don't you sit down and draw Mommy a picture? And all of a sudden, everything would become very quiet."

Thompson's fourth grade art teacher recognized her pupil's creative talent and increased focus too and acknowledged it to the class. In turn, Thompson began to get a different reaction from her peers, her first taste of admiration rather than scorn.

"They would ask about my art and I would think, 'Oh my goodness, they're asking about me!'" she says. "I realized I love art because it helps me feel more focused, just like the meds do, and that helps you with your talent. So I decided I'd rather take them than not be able to do my talent."

Her first sale was to her 13-year-old brother Roy, who bought her "Daily Diet Chart" for $2. ("It should have been $3, but I discounted it," admits Thompson, who is close to her sibling.) Recently she sold her self-portrait from the FACEing Mental Illness art show for $75 to someone who saw it at the exhibition opening, an adult who had himself struggled with ADHD at Thompson's age. Those affirmations lit an entrepreneurial fire. Recently Thompson came up with a name for her own business -- ACBA ("Art Can Be Anything") – and is channeling her profits into art supplies to fuel her progress.

"When I didn't have any friends, meds made me feel different," she says. "I was just this silent, shy girl, afraid to talk. Now I've started realizing that I'm really cool and I have talent. It's so great to know I have something I'm good at and it's given me a chance to show the world who I am."

It's also made her something of an advocate. One day not long ago she came home from school and asked her mother what the word "mental" meant.

"Because people would say it at school like it was a bad thing," she explains. "My friends would say, 'Oh, she's *mental!*' and then laugh."

They looked the word up in the dictionary and together read the definition – "relating to the mind." Discovering there was no negative connection was not only "a huge heads up," Thompson says; it also sparked a determination to set her peers straight.

"Before when my friends would use that word, I would just stay quiet and try to find a different topic," she says. "Now I think it's mean and rude and it's a bad thing that I let them do that."

Recently, when she noticed a new student at school was being ostracized, she made a point of approaching her at lunch and starting a conversation.

"When people talked about me, it made me feel left out," she says. "I had to learn I can't make them make me feel like that. So I said to her, 'Hey, I understand. I know how you feel.' I tried to make her feel courageous too.

"It helps when you share. It helps get the feeling out. And when you talk it through, it helps them get a better understanding. I like to share my art with people who understand how I feel."

MARCIA GOLDNER TREIGER

It wasn't until she stepped into a photography lab as a student at an art college in Philadelphia that Marcia Treiger found what felt like her true calling.

"It was magic," says Treiger who, at 64, has spent most of her adult life as a college photography professor. "It was the kind of thing where you are so immersed, there is no such thing as time. It was the first time in my life I felt I could really express myself."

Raised in suburban New Jersey by older parents — her mother was 44 at her birth and as a toddler, she remembers thinking, "Who is that old man?" about her father — and teased and tormented by two much older brothers, her early years were filled with angst and confusion. Taking pictures, a creative process she sees as an opportunity to "raise questions, not give answers," was a welcome refuge.

After enjoying a prestigious photography fellowship in Paris, she received her fine arts degree and was accepted

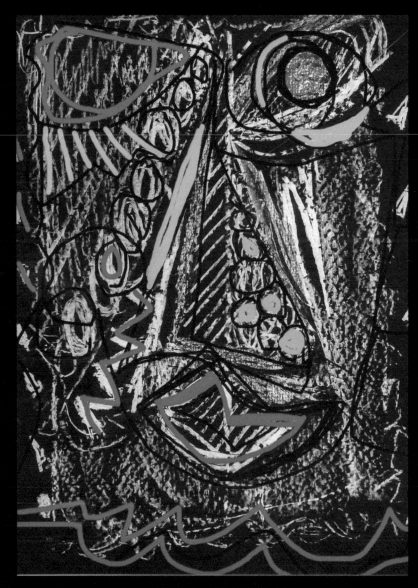

TITLE: BLUE MARCIA

"Being bipolar has been the main focus and challenge of my life. Even in my most stable times, feelings of sadness and isolation would surface at night. Nature, water, trees, wildlife, all calm my spirit. Every day is a new adventure. I try to live as stress-free a life as possible, and that includes a lot of alone time. And belief in a higher power that guides me every moment."

to graduate school. There she spent countless hours in a darkroom, enveloped in her art and the odor of chemicals. It was a casual remark from a professor about her weight — she'd put on about 10 or 15 pounds at school — that threw her into a tailspin.

In three months she slipped from 130 to 83 pounds and began to exhibit "all the unusual manic traits" as she puts it — anger, paranoia, delusions of grandeur. Hospitalized, she was treated for severe malnutrition, but doctors couldn't settle on a mental health diagnosis. Treiger's mother refused their only recommendation — electroshock therapy.

"They told her, 'Then she'll be a vegetable,'" Treiger recalls, "and my mother said, 'We'll take our chances.' That was my first experience with the mental health world."

Released at 110 pounds with an ironic warning ("Don't gain any more!"), she retreated to the couch in her parent's den, and to the solace of food.

"I ate and ate and ate," Treiger sighs. "I went from 110 to 180 and I've struggled with my weight ever since."

On Lithium, "a little pink pill once a day" that she would take for the next 30 years, she regained her equilibrium and began a teaching career at a state university. Over the next three decades she would continue to share her expertise in photography with students, including at her alma mater, the Moore College of Arts, the Art Institute of Philadelphia and the Antonelli Institute, a photography and graphic arts school.

But she would also experience sporadic but continual setbacks; emotional stress could, and often did, cause both her physical and mental health to deteriorate. Using now-antiquated terms, she refers to them as "nervous breakdowns." One was triggered by the deaths of her co-worker, a student and her father, all within a year. Another was precipitated by a gall bladder attack. A third, more severe, followed the death of her husband after a contentious decade together;

she'd married him in her 40s with some degree of uncertainty, but fearing she might not have another chance at love.

That one left her a near recluse. Other than teaching a single course at Philadelphia University, which gave her "the only reason to get dressed," she spent the next four years wondering, "Am I ever going to have a life again?"

Eight years ago, she concluded she would die if she didn't make a major change. A mass mailing to every college with a photography department in Florida landed her a position developing a new department of digital photography in Tampa, where she moved in 2011. Three years later, she became entangled in legal action with the school and faltered again, institutionalized and on medications that exacerbated her agitation.

"For four months I had no contact with anyone and I was in horrible places," Treiger says. "I kept saying, 'Hey, I'm a college professor.' I was in a very scary place in my mind and I will never, ever forget it."

What came of that nightmare, however was another beginning, one in which she finally, and openly, acknowledged her illness and committed to rigorously maintaining the holistic health approach — medication, sleep, exercise and her art, all in consistent doses — that keeps her on an even keel.

"Most of my life I had low self-esteem and a lot of it had to do with the fact that I was hiding this big secret that I was bipolar," Treiger says. "It wasn't until I recently decided that this is who I am, that I felt liberated. It was like opening up Aladdin's magic lamp. All of a sudden people opened up to me.

"What we all want is kindness," she adds. "Why do we hide our light? Why do we hide who we really are?"

PAUL MATHISEN

Photo by Rachel S. O'Hara

In a closet of Paul Mathisen's small, dimly-lit apartment, there is a box filled with square chunks of wood, painted on one side. To stumble on them you'd likely wonder if they were scraps from a do-it-yourself project, or maybe pieces of some unusual puzzle. What they are, in fact, is something else: fragments of Mathisen's dream of becoming a working artist.

Once, these pieces were part of the large wooden panels on which he did his painting. Several years back, when a local gallery sold a few, they represented success. But in a fit of pique brought on by the recurring psychosis he has struggled with since his late teens, Mathisen sliced the remaining work into blocks, his art, like his life, splintered by his illness.

Sitting on his couch, a coffee table piled with art books in front of him, a drafting table in the corner, Mathisen, 42, shares a story of struggle and backslides, the first of which began in early adolescence when dyslexia and other learning disabilities surfaced.

"I couldn't read or write," he says. "And I wasn't much for talking either."

From an early age, he discovered art was something he was good at, a place where his creative imagination and manual dexterity overruled the academic. But it wasn't until he left public school – where he wasn't allowed to sign up for advanced art classes because of his learning challenges – and went to an upstate New York boarding school that he was allowed to indulge his interest, taking every drawing and ceramics class offered. He also excelled athletically, playing tennis, skiing and becoming the captain of the soccer team at 15.

On the advice of a teacher, he joined a college art program led by Marvin Sweet, an award-winning ceramicist. In clay, Mathisen found his métier and in Sweet, a mentor, albeit an often demanding one. But as his passion blossomed, his connection to reality shrank. The onset of psychotic episodes, a difficult relationship with a woman and deep depressions he self-treated with alcohol eventually led to a suicide attempt. He left school and moved into his parents' Massachusetts basement, a situation that didn't work for either of them.

"I was broken," Mathisen says. "I couldn't even look anyone in the eye. And my parents didn't understand. They

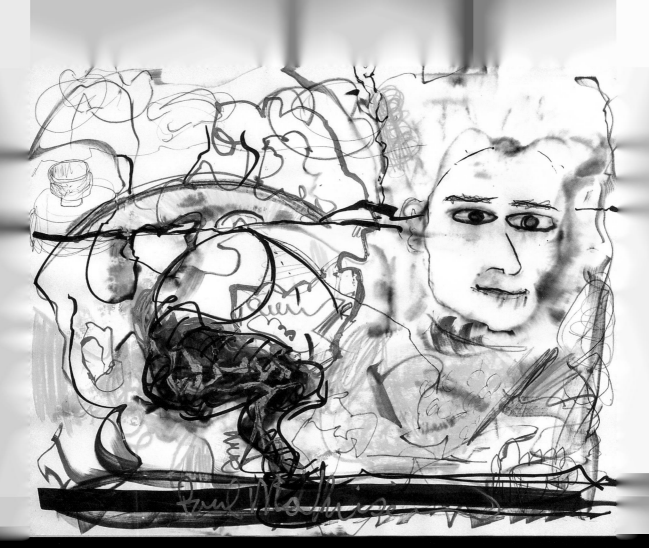

SELF PORTRAIT

...as misdiagnosed for years with bipolar I disorder and was taking all the wrong medications. ...past two years I have been properly diagnosed with schizophrenia. Now that I am on the ...dication, I have an entirely different life. I have an apartment and a job at the YMCA and ...ned I can multi-task in a stressful environment. I work out 4-5 times a week and have lost ov... ...nds. I will be sober for three years in May. I am able to effectively communicate with others... ...be paranoid all the time. I do still have feelings of paranoia, but they do not take over my li... ...the future, I hope to be able to create art again and be represented by an art gallery agair... ...l is to continue to be a productive member of society, to raise awareness regarding mental i...

saw me as smart and educated and couldn't figure out why I couldn't get it together."

Scouring the Internet for help, he stumbled on something called DBT (Dialectical Behavioral Therapy), a modified form of cognitive behavioral therapy that changes patterns by helping people identify the "triggers" that lead to suicidal thoughts and self harm. For the next year, he went to an outpatient program every day; some of what he learned he still uses today.

"It reprogrammed my brain and changed my entire life," he says. "I still struggled but it helped me understand it's not the situation but how you cope with it. I don't think I'd be alive without it."

More balanced, he joined an employment program for those with mental illnesses and began to rebuild his life. But when his parents decided to move to Florida and his brother chose to go as well, he joined them. The brothers shared a Sarasota home their parents purchased and Mathisen, now on disability, starting seeing a psychiatrist and taking medication. Yet over the next decade, as he cycled through a series of jobs-- first at a newspaper printing plant, then for a small landscaping company and finally putting inserts in newspapers – his illness continued to sabotage his progress. Either he would be fired for irrational behavior or, feeling paranoid, he would quit before he could be dismissed.

His passion for art, alone, endured. After making the rounds for years, he finally got a local gallery to give him some wall space. A small show in St. Petersburg followed. His spirits lifted after he sold a few pieces and met a woman, also an artist, with whom he discussed opening a ceramics studio.

"I didn't really admit I was an artist until I got in a gallery," he says. "Back then, I was very excited. But it didn't happen."

Despite multiple medications – for psychosis, anxiety and mood stabilization – Mathisen's symptoms persisted. As a coping mechanism, so did his drinking. Meanwhile, he ran up a five-figure credit card bill buying art supplies and studio time. More than once, his parents, who had turned

to the local chapter of NAMI (National Alliance on Mental Illness) for help, bailed him out.

Knowing he needed help, Mathisen went through a rehabilitation program several times, but "it never stuck." His hands began to shake so badly he couldn't even do his art anymore. At one point, overwhelmed by a fear that someone would steal them from him, he swallowed the index cards containing ancient ceramic glaze recipes his mentor had given him. Then, convinced he was dying, he raced to the emergency room.

Three times he was involuntarily hospitalized, twice in one month. On the final stay, he was given a different medication, one that at last controlled his psychosis. When the dosage was gradually reduced to a level that allowed him to function, he began another painful climb toward recovery. At first, his progress was agonizingly slow.

"In the beginning, I kept a list and crossed things off one by one," he says. "Turn off the alarm. Get up. Brush your teeth. Comb your hair. It was all I could handle."

Not quite two years ago, Mathisen started going to exercise at the YMCA with a staff member from the group home where he was living. That evolved into a job maintaining the fitness floor and, last year, to a position at the front desk. He has lost 50 pounds – weight gain is a common side effect of anti-psychotics – quit smoking and has been sober for three years. The "fuzz" in his brain has begun to diminish.

His debt nearly paid off, he recently signed up for a ceramics class. It will be the first time his hands have touched clay for more than five years. He is excited, but wary. The idea of earning his living as an artist now feels like just another delusion.

"I find solace in the simple things," he says. "I like to touch things, sculptures. What I really think people and life are about are the smallest things. It's the small things that make the biggest noise."

Photo by Mike Lang

HARRIET "HIBBY" WENGER

Harriett "Hibby" Wenger was just 10 years old when her mother died of a brain tumor at 49. The tragic event set the tenor for the rest of her life says the former special education teacher, now 82.

"It was around Easter," says the petite Wenger, sitting in her immaculate town home, meticulously dressed and coiffed. "I built an altar in the woods and every day after school I would go there and pray she would come back. I thought if Jesus came back, maybe she would too."

But there was no miraculous resurrection, only a difficult childhood as the youngest of three born to a once prosperous father who lost his entire fortune in the Depression and his own father and brother to suicide. The family, teetering on the edge of extreme poverty, shared a home out-side Buffalo, New York, with five other relatives, including Wenger's grandfather, who betrayed her trust with inappropriate touching.

From that early age, and many times thereafter, Wenger's inclination was "to flee rather than fight." She was 13 when she ran away from home for the first time, riding her bike far into the countryside. At 19, she married precipitously and "for all the wrong reasons," just to escape the cramped, obligation-heavy household that was all she'd ever known. Though the marriage quickly became "not what I anticipated," she remained, hoping that in having children she would find someone who would love her limitlessly and care for her as much as she would them.

But when her first born of three sons suffered mild cerebral palsy after a difficult birth, his challenges just added another weight and layer of responsibility, one that sent Wenger back to school for a master's degree in special education. It gave her life direction, she says; she would devote the next 33 years to teaching special needs children, long after her own had achieved independence.

Yet purposeful direction did not equal passionate pleasure. Time after time, year after year, Wenger fought a chronic and unshakeable depression that settled on her

41

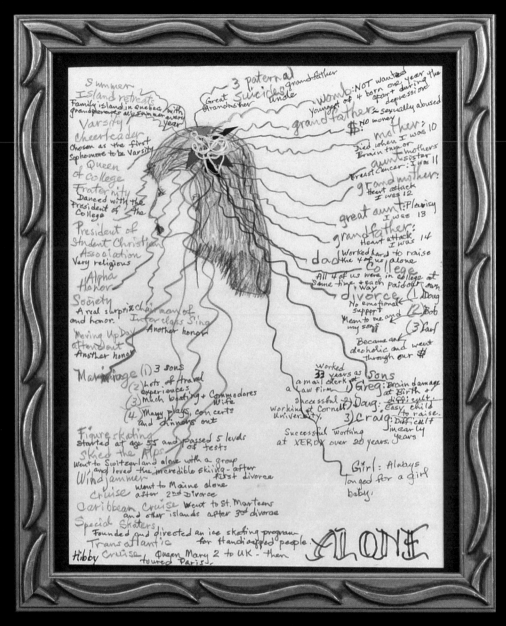

TITLE: ALONE

"Much of my life, I have felt alone due to the devastating illness named dysthymia, which was only recently properly diagnosed as my debilitating condition."

like a suffocating blanket despite regular medication and therapy. Thoughts of suicide — and occasional actions to suit -- visited regularly. Once she drove to Niagara Falls and perched her car at the edge of the escarpment, trying to summon the courage to drive over. Another time she drove to a city park, stuffed the exhaust pipe, rolled up the windows and positioned a suicide note on the dashboard. When darkness fell and she had not yet lost consciousness, she became afraid and drove home, reading failure into even this most self-destructive action.

Her first marriage ended in divorce after 13 years; two subsequent unions took her to Massachusetts, then Omaha, then back to Buffalo and eventually to Florida but suffered similar endings -- as did, recently, a 16-year "friendship" with an elderly neighbor. As badly as she had always wanted someone to take care of her, Wenger was always the one who wanted out.

Rarely, there have been moments of enjoyment and gratification — receiving an award from a national association for the learning disabled; taking a skiing trip in the Alps and a Windjammer sailing cruise on her own between marriages; her sense of pride after taking up ice skating at the age of 55, passing five levels of expertise, and creating a nonprofit organization that provided adaptive skating experiences for children with disabilities. But instead of feeling good about her ability to make things happen on her own, the accomplishments only underscored her loneliness.

"The best things in my life, I made happen for myself," Wenger says. "I kept wanting someone to take care of me, but I gave and gave and gave and I never got in return."

Nothing filled the void of her "longing to be loved, to be taken care of." Not her once-fervent religious faith, not meditation, or yoga nor a laundry list of anti-depressant medications. Every year on her birthday, December 19, the weight descends; growing older, she has only become more despairing of ever changing the cycle.

"It's been with me my whole life," says Wenger, who pulls out a scrapbook with a yellowed clipping of a poignant poem she wrote in high school, titled "Alone," that did not elicit the help she was hoping for. "I don't get joy. Sometimes it's like I'm numb and going through the motions of existing. I just don't see what I have to look forward to."

It is only recently, after years of psychiatric visits, that Wenger received a diagnosis of dysthymia, or serious and chronic depression. Putting a name to her unhappiness, however, has done nothing to diminish it.

"What's there to look forward to but more of the same?" she says. "There is no cure. If you have bad hips, you can have surgery. But this is invisible. You're supposed to just put on a happy face. I want to be happy. I'm envious of people who are. But I don't believe it's possible."

Still, there is some small part of Wenger that refuses to give up. Every Thursday night for the past 12 years she has put on nice clothes and driven herself to the Happy Hour at the Bijou Café, where she nurses a Cosmopolitan and makes friendly conversation with the other regulars.

"I call it 'playing lady dress-up,'" she says. "My 'liquid happiness.' I do enjoy getting out and the only way I do is if I make it happen for myself."

For the last seven months, she's done the same thing at Michael's on East's piano bar, where she recently met a couple who generously invited her to Christmas dinner at their home. As is her nature, Wenger brought with her a pie and handmade gifts for the hosts and their child.

Recently Wenger wrote to one of her sons, to whose child she had bequeathed her ice skates when her skating organization derailed after several successful years, and said she was considering taking up the sport again.

"I was thinking that maybe I ought to get those skates back," she says. "That's a wonderful feeling when you're gliding along on the ice."

On the ice she is free. Unburdened. Light. Admirable. It's a feeling of elation that has eluded Hibby Wenger on solid ground.

ERICA KARP

Photo by Dan Wagner

Erica Karp was the middle child of Holocaust survivors who settled outside Chicago, and the first of their three daughters to be born in America. Both her father, a physician, and her mother, a housewife, were scarred by their wartime experiences and their angst left an indelible mark on her childhood.

"It was hard growing up with parents that were traumatized," says Karp, who recently became a full-time Sarasota resident after retiring from a successful career in social work. "Things in our home were not normal. My mother was very nervous, my father very irritable. I was raised not to trust people. It shaped me a lot."

She remembers her first episode of depression manifesting at the tender age of 5 as a refusal to eat. Her father reacted not with sympathy, but a threat; if she didn't submit and join the family for meals, he would put her in the hospital.

"He gave me the message that it wasn't OK to be depressed or to show your feelings," Karp recalls. "I learned at a very young age to pretend to be normal. And pretending to be normal is exhausting."

As soon as she graduated from high school, Karp escaped for a semester at the University of Mexico, then settled in at the University of Illinois in Champagne-Urbana as a psychology major, a choice that taught her "focusing on other people's problems was a great way of not facing my own." She couldn't outrun her negative thoughts and black moods, but she learned to become "a really great actress in my daily life."

While still in college, she married, at 19, a man who had been her English teacher during her senior year of high school. She also began taking birth control pills, not realizing the estrogen in the prescription would upset her hormonal balance, exacerbating her depression to the point of a suicide attempt at 20.

She saw a psychiatrist who she hated and who put her on medication that caused a severe reaction. She abandoned both.

TITLE: TIME TO COME OUT OF THE BOX

"By participating in this project I am coming out of the box I have been hiding in most of my life. I have a diagnosis of major depression. Most of the time it is under control with medication, meditation and mindfulness. But when it is not, it is a life-threatening illness. It is time to let people know that even with this diagnosis, I have been able to raise a healthy son, have a successful career as a social worker and, on the third try, have a happy marriage. Stigma is a terrible thing. My disease does not define me as a person. I strive to thrive in spite of its daily challenges, which

She stayed in school, but stress was a constant trigger, and eventually she went to the dean of her graduate school department to confess that she could no longer handle the academic pressure and needed to leave the program. He refused to let her go.

"He would not let me drop out," Karp recalls. "He said, 'You're good at compartmentalizing and you're doing great with school. It would be a disservice to let you go.' And he was right."

Thus continued a life of compartmentalizing, pretending and covering up the darkness within with a falsely positive exterior. Her social work degree led to a job in case management for the elderly, but her marriage dissolved after five years, prompting even more thoughts of failure and hopelessness.

A second marriage brought a much longed-for son, her only child. Motherhood agreed with her and a maternity leave from her agency job would eventually lead to her "hanging out my own shingle" and working in geriatric case management in the Chicago area for more than two decades. But when her son was just a toddler, the depression descended with a vengeance that made her fear she was "taking it out on him."

At age 32, for the first time in her life, she entered serious treatment, taking an anti-depressant and undergoing regular talk therapy. When a herniated disc led to six months of disability when her son was 5, the art classes she took during her recuperation gave her a way to express her anger and pain and take a break from the incessant "negative thinking" that was her biggest curse. From that point on, her art — which has now blossomed into everything from painting and drawing to sculpture and photography — became a therapeutic outlet.

But it wasn't until many years later — after another divorce and her happy third marriage to a man who "is a happy-go-lucky person who always sees the glass as half full" — that she took a mindfulness course that taught her behavioral conditioning practices that worked to counter the nagging negative voice in her head. Raised in the Jewish faith, she found her spirituality branched out as she studied Buddhist meditation and learned "how to breathe and pull yourself back to the present moment."

"I learned meditation and how to challenge my automatic negative thoughts," says Karp. "So much of being depressed is obsessing about the past and worrying about the future. Meditation helps me be in the present, and the present is do-able. The present is what you've got to work with."

Ten years ago, a friend and member of Karp's synagogue committed suicide. That led to the establishment of a depression support group at the temple and a task force aimed at encouraging people to come forward with their mental health needs. It was the first time Karp disclosed her struggle to others in the group. But only now that she is fully retired has she chosen to be public about her own lifelong struggle.

"I've had a great professional career as a social worker and business person and most people never knew I suffered with depression, though it's something I still deal with on a daily basis," she says. "But I wasn't comfortable with going totally public while I was working. I thought people would think, 'How can someone who is struggling with her own mental health issues help me with my family issues?' And you always wonder if people will see you differently when they know you have a diagnosis."

Her motivation in stepping forward now, she says, "is to prevent other people from going through a similar life of struggle."

"Mindfulness is something that should be taught to children in school; it's more important than math," she says. "People should be exposed to it as early as possible. You certainly don't have to have a mental health diagnosis to benefit from it."

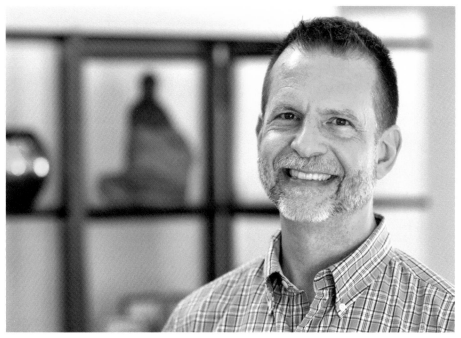

Photo by Tom Bender

DAN AUSTIN

When Dan Austin was 8 years old, his father died of lung cancer after a precipitous decline. Until then Austin — and his three older sisters, Nan, Jan, and Pam ("My parents obviously had a sense of humor") — had enjoyed a very "normal, stable childhood," a middle-class lifestyle in Milwaukee and the nurturing of a stay-at-home mother.

In the many years since, Austin, 53, has often wondered if the comment his grandmother solemnly made to him at the funeral — "You're the man of the house now" — had anything to do with the pressure he would later put on himself or the loop of negative self-talk that became an earworm in his mind.

"Saying something like that to a child has a very negative impact," says Austin, seated in the living room of the new home in Bradenton he recently purchased with his husband, Thom Gravelle, moving boxes still unpacked. "I took it very seriously."

By the time Austin entered a college prep high school program, his sexual identity — he knew he was gay but was reluctant to come out — added to his level of stress. Though an excellent student, he was increasingly overwhelmed by school work and his own unrealistic expectations. The combination of rising academic pressure and flagging self-esteem pushed him to seek help from a teacher, but that help wasn't readily available. One day he walked out of class in the middle of the day and "the next thing I remember I was standing on top of a bridge."

"The only thing that saved me was a police officer who talked me off the bridge," Austin says. "But that's all he did. I went home and didn't share with anybody what I'd done.

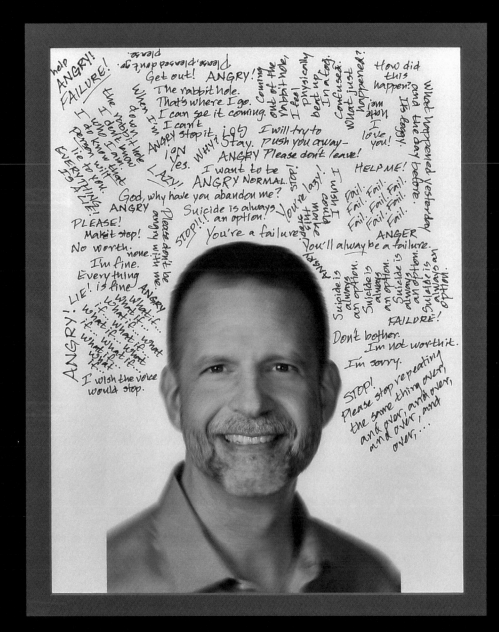

TITLE: UNTITLED

"It's the 'voice in my head' that's one of the most disturbing aspects of bipolar disorder for me. During depressive episodes, the self-talk can be incessant – the non-stop loop of destructive negativity. It's such a blessing and relief when the voice stops and I can live again."

I didn't seek help. I don't know if I even knew to seek help."

Austin had been confirmed by the Wisconsin Synod, the strictest and most traditional arm of the Lutheran Church and was already, at 17, an assisting minister. So he headed to college as a religion major, hoping his faith would provide a steadying direction. But eventually he grew "tired of being told I was going to hell." He switched to a different Lutheran branch, one of the first to adopt full inclusion of gays and lesbians, and found a stability the rest of his life lacked.

Yet he remained confused about his purpose and goals. Several times he switched schools and areas of study. Ultimately he graduated as a communications major and began many frustrating years working for advertising agencies, where layoffs were common. He also saw the first of many therapists, all of whom diagnosed him simply with "situational depression" and anxiety.

But Austin's volatile mood swings, hypermania, bursts of unpredictable anger and periods of paralyzing depression indicated something more. Still, he could never simply admit to doctors the hellish cycle of mania and depression he was caught in. Those closest to him, however, recognized it as something more than moodiness.

"My former partner made a comment once: 'Do you know how difficult it is to deal with you?'" he says. And I said, 'Spend a day in my head and you'll understand difficult.' Once that self-talk starts, it's incessant. The voice will not stop. But it's surprising what one can keep from a doctor. I have never fully disclosed everything to any therapist I've ever gone to."

Feeding his volatility was confusion over his spiritual objective. Given that openly gay pastors were now acceptable, Austin hadn't yet closed the door on becoming a pastor. When his relationship with Gravelle grew to the point where they were considering marriage, he joined his partner in taking confirmation classes, "needing to confirm I believed in the basic tenets of Christianity and feeling if I could not support it 100 percent, it was not my calling."

Then, on a weekend church retreat, someone looked at his grinning face and said, "Dan, nobody's that happy all the time."

"That was a turning point," he says. "It was the moment I realized people could see through the persona I was projecting. That 'put on a happy face' is really easy when you're manic. It was the depressive episodes I kept so quiet that no one knew."

In his forties, Austin saw a therapist who finally diagnosed him with bipolar disorder, taking him off the anti-depressants that were, in fact, exacerbating his condition, and putting him on appropriate medication.

"It made a huge difference, almost immediately," Austin recalls. "After that, life changed. I felt more consistently stable. It doesn't solve the problem, but it evens things out."

Tired of the unpredictability of employment in advertising, Austin opened his own marketing business in 2002 and he and Gravelle began visiting Florida annually, thanks to a friend who shared her Venice home. After their marriage, they contemplated a permanent move south.

Within months of Austin's arrival here last year — with "no friends, no family, no business and no network" — he was selected to develop a local chapter for a national nonprofit geared toward educating students about mindfulness and mental health consciousness.

Being open about his own condition was never an obstacle. Back in Milwaukee, when a writer for a business publication had approached him, looking for connections to potentially interview subjects for a column on mental health, Austin told him, "'You don't have to look any further. I'll do it myself.'"

Gravelle, who stayed behind to finish a job commitment, joined his partner in Florida last January — not long before the organization employing Austin abruptly abandoned its efforts to establish an affiliate here. That catalyzed another depression and more of his relentless, denigrating internal conversation.

Austin has since returned to his marketing practice, but still hopes to find a way to continue his advocacy. It is important, he says — and not just for those who hear his story.

"People need to know," he says. "But if part of the goal is to raise awareness of mental health issues, I need to be able to do that myself."

LISA WHELAN

Lisa Whelan's life was stuck in overdrive. As if being a seventh-grade middle school teacher with a Teacher of the Year reputation to uphold wasn't demanding enough, she was filling every waking moment with a profusion of other activities and responsibilities. Running the school ski and newspaper clubs. Participating on the school crisis management team. Taking classes toward her Ph.D. Driving from her New Jersey home into New York City on weekends to cram in Broadway shows, museum visits and fancy dinners.

"I got up early and I just went all day long," says Whelan, her long blonde hair brushing against the head of her tiny 3½-pound Yorkie, Junebug, seated on her lap. "I decided if you couldn't keep up with me, there must be something wrong with you."

Some days she'd arrive at work before dawn, careening from one thing to another, snippy and impatient with anyone who didn't appreciate her productivity. Other days she'd call in sick, sleeping nonstop or crying uncontrollably for so long she had to ice her eyelids to take down the swelling. And why was she shopping for long sleeve shirts in the Jersey summer heat to cover the cuts she'd begun to dig into her wrists and forearms? If she was such a success, why was she thinking about suicide?

When it came, in the spring of 2002, the crash was abrupt, a precipitous ricochet from the classroom to an acute psychiatric ward, where she was diagnosed with bipolar disorder and administered electroconvulsive therapy.

"After that, everything changed," says Whelan, now 50, seated in her small but tidy Lakewood Ranch apartment. "I

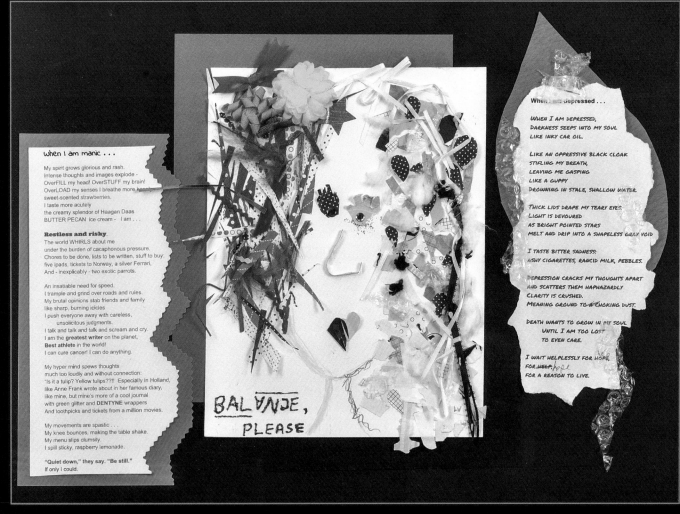

When I am manic . . .

My spirit grows glorious and rash.
Intense thoughts and images explode -
OverFILL my head! OverSTUFF my brain!
OverLOAD my senses I breathe more keenly
sweet-scented strawberries.
I taste more acutely
the creamy splendor of Haagan Daas
BUTTER PECAN ice cream - I am . . .

Restless and risky.
The world WHIRLS about me
under the burden of cacaphonous pressure.
Chores to be done, lists to be written, stuff to buy:
five ipads, tickets to Norway, a silver Ferrari,
And - inexplicably - two exotic parrots.

An insatiable need for speed,
I trample and grind over roads and rules.
My brutal opinions stab friends and family
like sharp, burning icicles
I push everyone away with careless,
 unsolicitous judgments.
I talk and talk and talk and scream and cry.
I am the **greatest writer** on the planet,
Best athlete in the world!
I can cure cancer! I can do anything.

My hyper mind spews thoughts
much too loudly and without connection:
"Is it a tulip? Yellow tulips??!! Especially in Holland,
like Anne Frank wrote about in her famous diary,
like mine, but mine's more of a cool journal
with green glitter and DENTYNE wrappers
And toothpicks and tickets from a million movies.

My movements are spastic . . .
My knee bounces, making the table shake.
My menu slips clumsily.
I spill sticky, raspberry lemonade.

"Quiet down," they say. "Be still."
If only I could.

BALANCE,
PLEASE

When I am depressed . . .

WHEN I AM DEPRESSED,
DARKNESS SEEPS INTO MY SOUL
LIKE INKY CAR OIL.

LIKE AN OPPRESSIVE BLACK CLOAK
STIFLING MY BREATH,
LEAVING ME GASPING
LIKE A GUPPY
DROWNING IN STALE, SHALLOW WATER.

THICK LIDS DRAPE MY TEARY EYES.
LIGHT IS DEVOURED
AS BRIGHT POINTED STARS
MELT AND DRIP INTO A SHAPELESS GRAY VOID.

I TASTE BITTER SADNESS:
ASHY CIGARETTES, RANCID MILK, PEBBLES.

DEPRESSION CRACKS MY THOUGHTS APART
AND SCATTERS THEM HAPHAZARDLY
CLARITY IS CRUSHED.
MEANING GROUND TO A CHOKING DUST.

DEATH WANTS TO GROW IN MY SOUL
UNTIL I AM TOO LOST
 TO EVEN CARE.

I WAIT HELPLESSLY FOR HOPE,
FOR HELP, *hope*
FOR A REASON TO LIVE.

TITLE: BALANCE

"I found inspiration for my collage in my poetry. Words spur my creative juices. When I write, I select thoughtful words, fonts, colors, sizes, etc. to verbally illustrate my 'ups' and 'downs' dealing with bipolar disorder. To create my collage 'face,' I chose specific colors, materials, shapes and textures to visually represent the sharp difference between mania and depression. I hope others recognize that mental/physical/emotional balance is vital to keeping one's head together, to staying whole, to feeling well."

lost my job, my car, my independence. I thought my life was pretty much over."

After three months in the hospital, she began to get better — or so she thought. But when she begged to go back to her teaching job, her psychiatrist refused to write the necessary note to the school district testifying to her readiness to return; he did not think she was stable enough. And though she now agrees with the assessment, at the time Whelan was devastated.

"I had the best life," she says. "I believed I was a great teacher. When you've done that for 14 years, it's in your blood and your soul. To take that away was like cutting off my arm."

Released from the hospital, her parents put her possessions in storage and moved her home. Numb, foggy-headed, gaining weight from new medications and still seriously depressed, Whelan was nearly immobile. But her parents refused to accept her cries of "I don't feel like it!"

"They would not allow me to sit around and not to take care of myself," Whelan recalls.

They outlined a daily routine for her, one that started as simply as: Get up. Take a shower. Take your meds. Eat breakfast. And as she began to revive they channeled her into regular treatment, from psychotherapy to support groups.

Enrolled in a hospital day program, Whelan took classes that provided structure and met peers who eased her social isolation. She met the man who would become her husband (he was diagnosed with schizoaffective disorder) in the horticulture therapy program where, as she says, "we not only learned to stop and smell the flowers, but their names and how to care for them." Eventually, she began teaching some of the program's journaling and art classes herself.

After three and half years, she made the "scary" decision to move on. She and her husband, both now on disability, moved to Florida to join her parents, who'd retired to Bradenton. But the marriage, which Whelan says was spurred by her desire to have children, was fraught with challenges. Her husband's symptoms of paranoia escalated; several pregnancies ended in miscarriages and one was terminated after it was determined the fetus carried a fatal genetic defect. At 49, Whelan had what she calls "a really good midlife crisis."

"I just couldn't do it anymore," she said. "I knew my whole life had to change."

She divorced, moved her husband back to New Jersey, got an apartment, her dog and a pure white cat, King Olaf, who outweighs Junebug times three. Recognizing the importance of a regular routine and stress reduction, she set a sleep schedule, worked on her food choices and signed up for a class at the YMCA that has helped her to lose 25 pounds over the past six months. She guards against her "tendency to be a hermit," but she's also careful about who she allows into her life.

"I'm cautious," she says. "A lot of people don't understand mental illness — they may say they do, but they don't. I'm careful to choose friends that accept there are days I just can't do it."

Dating, she says, is also a quagmire. She's tried match.com, "but everyone says they don't want baggage or drama," she says. Then there is the eternal dilemma about "when you tell someone."

Still, she is slowly rebuilding her life — not the frenetic life she once led, but a new, more resolved and purposeful one. She has returned to the art and music she always found therapeutic and, most importantly, to her writing. She's had essays published on pet therapy and the art of maintaining a relationship when you have a mental illness and she regularly enters writing contests. Recently, she was named one of three national finalists in a competition sponsored by a pharmaceuticals firm. Writing, she says, "is the one thing that gives me a high that's not bad for me." It gives her back the feeling of being successful again.

"When you have a mental illness, you lose yourself. You don't care," she explains. "Now I can take the time to find myself again. You learn you still have hands and a body and a face and that people can still see you."

She pauses for a moment, a shadow crossing her face. Then she adds:

"They can see me. But how do they see me?"

Additional Artists

SELF PORTRAIT

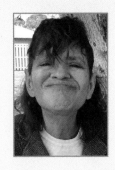

KAREN 'BUGSY' JULIANO

"They see my red hair, I dye my hair red so it stands out. When I smile they see my dentures, sometimes people are confused because of the way I hold my face in. They see me frowning. They see me frowning even if I'm happy. They wonder what they did wrong. It makes me feel sad because people tend to make fun of me. I have a hard time dealing with people because it doesn't make sense to me."

UNTITLED

SHERRY ELLIS

"My painting took shape as a portrait of how I thought our family unit grew over the years as a result of different parenting styles and various professional guidance through turbulent times. Being a parent is so rewarding and yet so daunting.

"I agree that there is no us and them. The entire planet plays a role, we don't live in a vacuum. I would like to see a study on who isn't affected by mental Illness? Think about it.

"Being an ostrich perpetuates lack of understanding, acceptance and change. Through articles, hands on research and projects like this one, we have the power to jump in, learn, promote awareness and try to understand one another."

Additional Artists

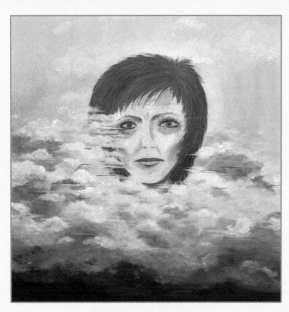

TITLE: STILL HERE!

SALVADORA FRENCÍ
AKA: FRANÇOISE MANDONNAUD STOTTS

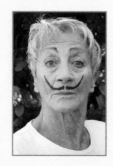

"Painting is my escape from reality!"

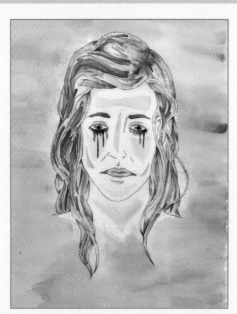

TITLE: COLORS

CHASE JERGER

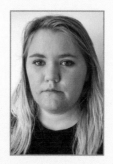

"I picked colors that represent my emotions. I have manic, bipolar disorder, so I jump back and forth through many emotions that I feel very strongly, with not much of a grey space between."

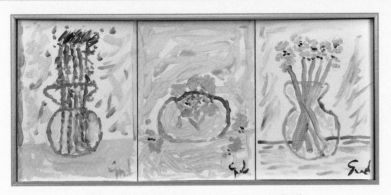

WILLIAM
DANDIE

TITLE: ODE TO THE LILY OF THE INCAS

"I'm in love with you and yet beholden. Your short time with me is a magical metaphor of a life well-lived. You're an example of the misconception of first appearances because the wildness of your resupinated leaves and skewed stems fill me with a sense of a raging storm.

"And then you emerge. On occasion seeming unlikely to survive only to quiet my doubts when the YOU I know bursts forth and I'm taught the resilience of life. Your unwavering presence epitomizes the essence of NOW. And yet petals do fall, telling me it's time to move on. Thank you, my Muse."

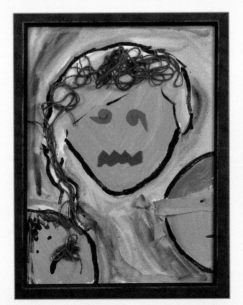

CHACY
AGNELLO

INTERGENERATIONAL TRANSMISSION

Additional Artists

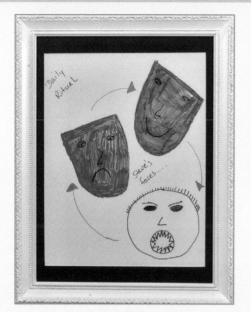

UNTITLED

STEVE
WILSON

"This drawing represents the mood cycle I go through every day, sometimes every hour."

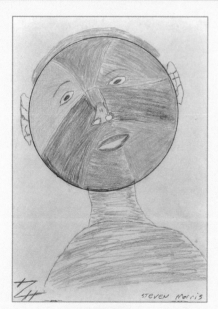

UNTITLED

STEVEN
MORRIS

"My portrait is a representation of me and my seven different personalities. I was diagnosed as bipolar with schizophrenia and multiple personalities. My portrait represents what I have to deal with on a daily basis. I am on meds to keep the other people in control."

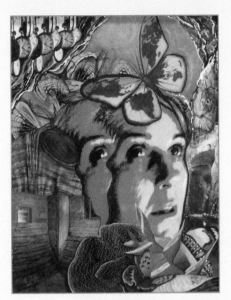

SELF PORTRAIT

KATYA
DELUISA

"Early child abuse left me with diagnoses of PTSD and bipolar, the latter creating terrible mood swings. As a single mother of three I couldn't afford therapy. Instead I created collages. The pictures symbolically depicted my internal struggle and this enabled me to identify and overcome many mental and emotional challenges. During the depressed episodes, I created art and during the manic, I exhibited it. I also developed therapeutic art programs to help others with the same techniques that helped me.
"I have been bipolar free for ten years."

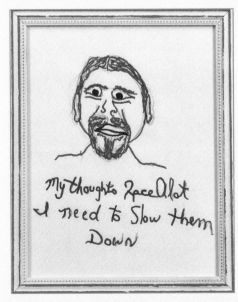

My thoughts RaceAlot I need to Slow them Down

UNTITLED

JOE
GALLAGHER

"My racing thoughts really get in my way when I talk to people. I'm getting help with that part of my life. I hope someday they will stop. Or calm them down?"

Additional Artists

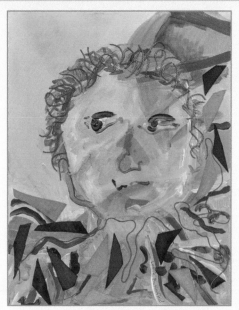

SELF PORTRAIT

LESLIE BUTTERFIELD

"Connecting people is my passion. My art is designed to form a connection with the viewer to create a sense of belonging and happiness. Trained as a designer and experienced in project work, I find that creating art brings me to a peaceful state of mind and gives me simple pleasure. I hope it does that for my viewers too.
"I thoroughly enjoyed my role as a workshop assistant in the FACEing Mental Illness project and appreciate how open and kind all the participants have been."

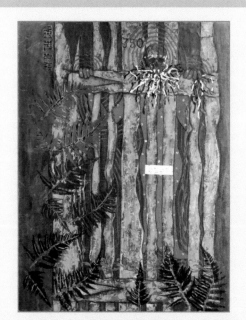

SELF PORTRAIT

ANN DARR

"I wonder who I might be if I had not been nearly drowned as a child by my brother. He stuffed my mouth with seaweed and held me under.
"Had I not been molested, bullied, called pimple face and fang in front of my peers. Had I not been programmed to keep my mouth shut or suffer the consequences.
"This is still embedded in my brain and haunts me 'til this day. Oh! The places I could have gone.
"This is the tip of the iceberg."

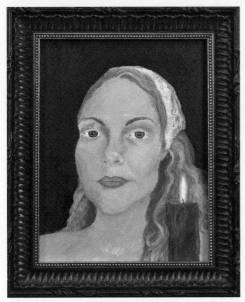

MADISON COKER

"Amidst the darkness a flicker of hope resides."

SELF PORTRAIT

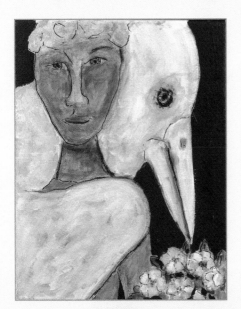

ANN BURROUGHS

"When asked to do a self portrait this image came to mind. I felt it was more important to talk about myself in relationship to mental health rather than draw a likeness. So this is filled with symbolism. A white raven represents the ascending spirit of an all-knowing bird. It's white to represent rebirth, renewal and protection from the reality of mental illness. The bouquet of flowers also symbolizes vigorous, alive reality that is so fragile. The figure represents me. The self being protected by the bird saying, "All is OK. I am there to be with you." The black background symbolizes the unknown."

"I feel it is important not to be afraid of mental illness. We are all functioning on a level that is meant to be. How we deal with this in our lives is important to ourselves, society and our family."

UNTITLED

Additional Artists

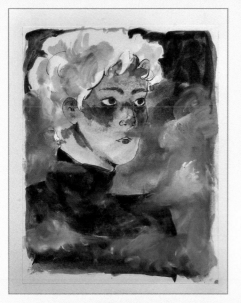

UNTITLED

SASHA BRAVERMAN

"I feel foggy and hopeless, but angry too."

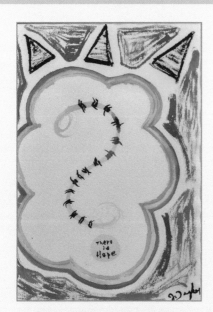

TITLE: BREAKTHROUGH

JODIE ELLEN TAYLOR

"Because I believe there is hope, the negative attitude and thoughts are held deep inside, whereas beauty and positive thinking is more abundant."

BEAUTY & DECAY

ELIZABETH TIMMS

"I once read a story about a king who was given a turtle as a gift. He decided the plain turtle wasn't worth his time and had it gilded with gold and precious jewels. Unfortunately, this made the turtle's shell so heavy that she couldn't move and died. My mental disorders are exacerbated by societal and familial expectations to be a certain way – the way I was before I was affected by these disorders, the way people of my gender or age are expected to be. This is represented by the jewels on the shell, the gilding weighing me down. The barnacles and plaque represent both the disorders corrupting the gilding, making me different from expectations, but also my acceptance of the disorders, showing that I may not be the useless gilded thing that's expected of me. I may be diseased and messed up, but I'm still beautiful and functional in way that matters to me."

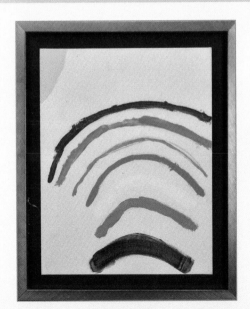

UNTITLED

CRYSTAL CARPENTER

"Walk on a Sunday. The water was cold and the fish were bite so go."

Additional Artists

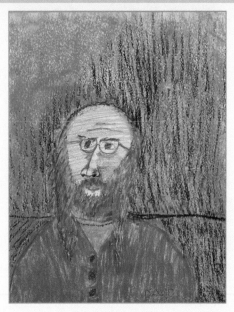

SELF PORTRAIT

DAVID FORNOFF

"Drawing is a talent given to me by Jesus. By growing it by practical skill, it becomes a tool for dealing with schizophrenia."

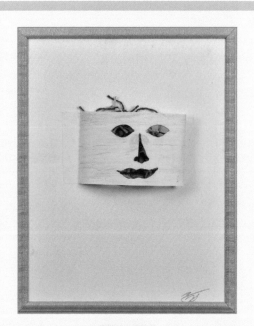

TITLE: BAJ

BRETT JONES

"A recognizable and pleasant presentation toward the front with a disorganized and uncertain mass obscured behind."

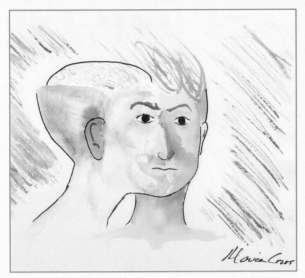

UNTITLED

MONICA
CROSS

"Everything I read has to travel in through my eyes, be reassembled in my brain and stay in the right order long enough to come back out in proper sentences. This has always been harder than it should be. By the time I have processed something, I have already gone through the task of analyzing it. For years people lined my intelligence to my reading speed. But that is not who I am."

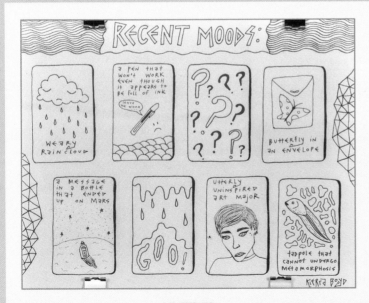

UNTITLED

KIERA
BOYD

"This comic-inspired drawing represents the constant fluctuation of moods I experience in my everyday life, as a result of my ADD, anxiety and depression."

Additional Artists

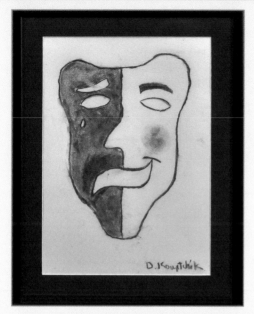

DIANA KOUPTCHIK

"The up and down emotions you go through on a daily basis, not just in recovery, but also in your everyday life."

TITLE: DAY TO DAY

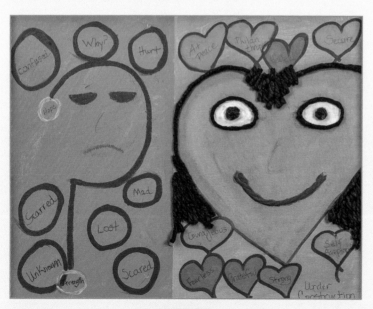

TRACY FIERROS

UNTITLED

TITLE: THINGS I LOVE

CAROL HIRSCHBURG

"This drawing represents how happy I am to have reached a point in my life where I can find joy in the things I love without the anxiety from which I previously suffered. I enjoyed this exercise, which was quite revealing."

UNTITLED

TOM CATE

"Every night I decide what I'm gonna wear the next day. First I decide on colors. Then shoes. It's like being myself. My clothes are nice and clean and hole-free."

UNTITLED

WILLIAM ANDERSON

"This is a picture of recovery from major depression after my first episode as an adult at 45. My life had had difficult times, but I weathered them sufficiently and this bout of depression descended on me when things seemed to be going along fine. It was severe, with symptoms like complete loss of interest and pleasure in life, loss of energy, difficulty in thinking and decision making, obsessive worry and insomnia. Within a few weeks of treatment with an antidepressant, my mood began to improve and all symptoms started abating.

"As a licensed mental health counselor, I want people to understand that all of us have mental and emotional distress and disorder at some point in our lives. We need to confront it when it occurs and treat it in order to enjoy the best life we can. My issues are in remission now."

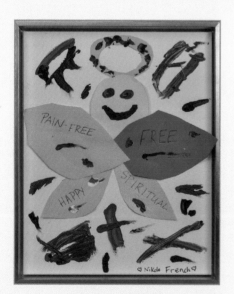

TITLE: FREEDOM

NIKOLE FRENCH

"I am set free from the control of addiction. I have found God and feel so happy and healthy. I don't ever want to go back to my old ways. I thank God every day for a new life!"

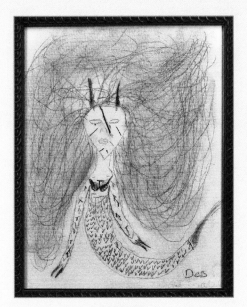

UNTITLED

DEBRA
CHADWICK

"I see myself as a dreamer, unhuman and scared."

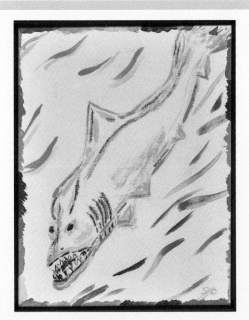

UNTITLED

SAM
CAPUTO

"I chose to draw myself as a fish, because I like swimming and I like the ocean. When people look at me, I hope they see me as a nice and friendly fish. Splish Splash."

Additional Artists

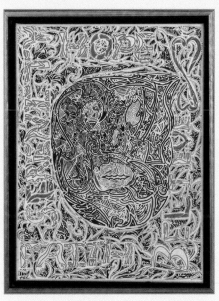

TITLE: CHAOS AS A VIRTUE

MICHAEL
QUATTRONE

"The lines and markings on this canvas represent any and every one who has ever been afflicted or affected by addiction. When we come together, we form something so simply complex, society has trouble understanding. But together, We do Recover."

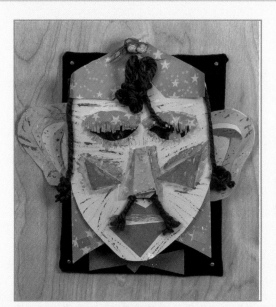

UNTITLED

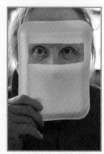

ALAN
BRASINGTON

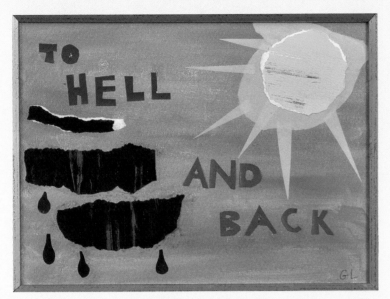

TO HELL AND BACK

GAIL
LEITMAN

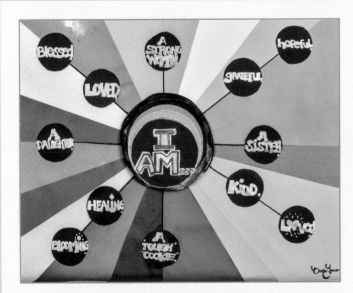

SELF-ACCEPTANCE MOLECULAR DEPICTION

BROOKE T.

"My perception @self is vital to my self-love, my happiness, health, future hopes & dreams, my family and personal relationship, my career...and etc. I must be aware of 'who' and 'what' 'I am...' accept the facts, reject the inaccurate labels, stigmas and/or beliefs, and learn to truly love myself...imperfections and all! "I am who I am. I believe what I believe. My past of my past. I know what I know. I love what I love. I feel what I feel. Therefore...I AM ME!"

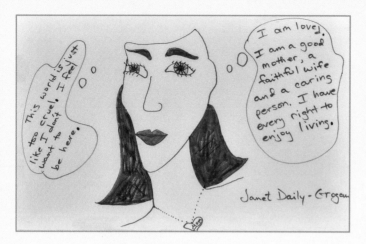

TITLE: DOUBLE MINDEDNESS

JANET DAILY-GROGAN

"I've learned to accept the sometimes contradicting thoughts and feelings I often experience and embrace myself as a whole. I may experience life differently than most others, but that doesn't make me wrong. I've discovered that having 'two minds' can be a talent too. I see deeply. I feel deeply. I understand deeply too."

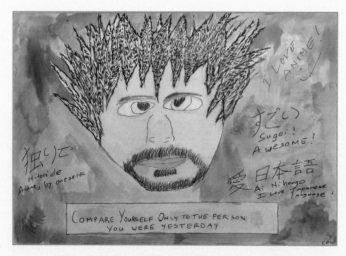

TITLE: RONIN, THE MASTER-LESS WARRIOR

KEATON WILLIAMS

"This piece was inspired because I am a huge fan of Japanese manga. I also like to watch Japanese anime. I have been studying Asian languages, such as Mandarin and Japanese, and Asian cultures, for many years. The artwork in those cultures is very unique and there is history in every piece. Their philosophies have helped to balance and center me in my recovery. That is what drew me to create this self-portrait."

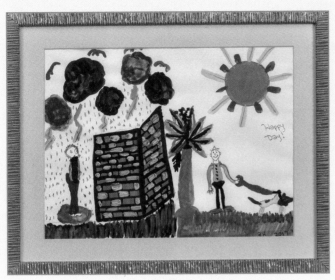

TITLE: SAD AND HAPPY DAYS

RAYMOND HINKLE

"When I'm doing drugs, I have a black day and build a wall between me and my family and friends. Clean and sober, I feel great, have self-respect and things go well around me with my family and friends. Enjoy the sober me."

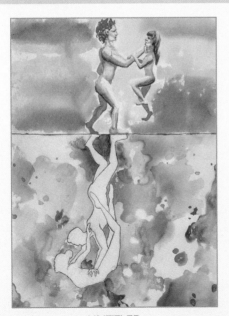

UNTITLED

HANNAH SHEPARD

"This work reflects the process of recovering from PTSD. While physical contact can trigger a lot of negative things, the process of normalizing it opens up a beautiful new world."

Additional Artists

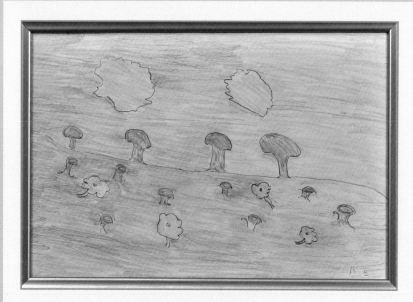

TITLE: TREES & STUMPS

ROBERT BRADEN

"This picture is based on what comes into my mind. It is what I was thinking because I like the outdoors."

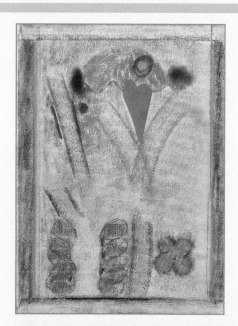

TITLE: VALENTINE'S MAGDALENE

JOZEFINA (BEATA)

"Inspiration: Dogs.
Thoughts: Drain.
Know to: About the closeness to my family."

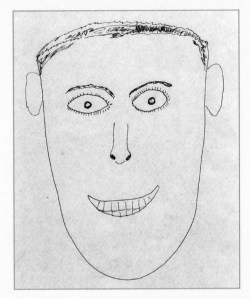

SELF PORTRAIT

JOHN M.

"People see me as a young man of seventy-five. They see some hair loss and broken teeth. People talk to me and discover I am not at a loss for words to reply. People perceive that I am self-confident and I can think during a conversation. I get along with just about every American regardless of their personality. People find that I like people and I am interested in everyone I meet.

"I exude contentment and happiness."

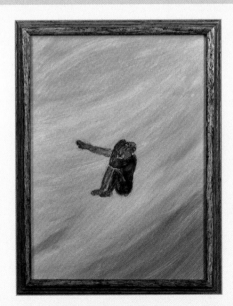

TITLE: REACHING OUT

ROBIN WIENER

Additional Artists

UNTITLED

THELMA COTE

"To rise above and among the chaos, to be your own beautiful mess."

UNTITLED

WHIT LANGDON

"I have been diagnosed for three years with schizoaffective disorder. It has been a very painful and arduous experience. The disorder has forced me to question the very nature of personal identity and has left me in a state of perpetual doubt. Living with uncertainty and at the whims of an often counterproductive nervous system has humbled me.

"I find peace in stillness and silence. This piece is my representation of what it is life when my mind is working against me."

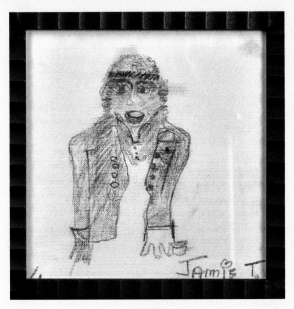

UNTITLED

JAMIE T.

"This is a self-portrait of me in the usual attire I wear at Prospect House. Nothing really unusual about it: denim jacket, head band and jeans. This however, is where the picture takes a macabre Twist of Fate. Look at my left hand, focus on the thumb. Sore, throbbing pain, excruciating. And I'm afraid it may be the end of a long journey playing guitar.

"The guitar has been my therapy, companion, inspiration in my life. This picture represents a tragic loss to an already painful existence. The end of the music. The story of my life for the past 50 years battle with drugs, alcohol, suicidal thought and loss. Now the GUITAR. God, why?"

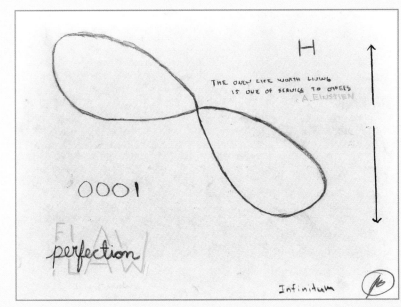

TITLE: INFINITUM

JASON BROWN

"Ultimate wisdom lays in the acceptance of the complex within the simple..."

Additional Artists

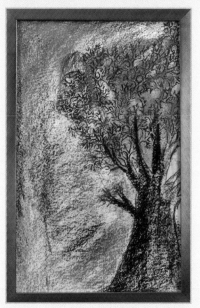

A GIRL LOST IN THE WORLD

DANIELLE VOSBURGH

"You can see the face hidden in the tree that is alive, but blackness has taken over."

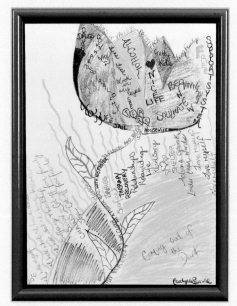

TITLE: COMING UNDONE

CAROLYN QUINN PERRINE

"Through abuse, I unraveled into someone I hated. Through recovery, I have become the person that was always inside...trying to come out."

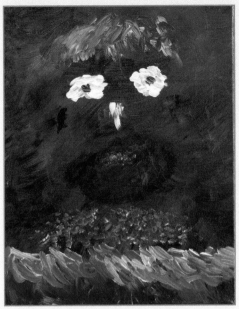

WADE CRAWFORD

"I appreciated the opportunity to be a part of this art workshop."

TITLE: ABOVE THE TIDE

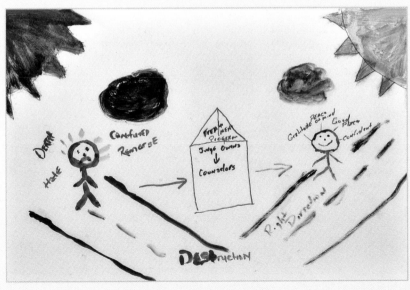

DAVID CORAHAN

"When I came to treatment program, I was in a very dark place. Thanks to the judge and counselor, I am in a lot better place now."

TITLE: LOST & FOUND

SELF PORTRAIT

LISA D'AGOSTINO

9/5/1993 – 6/6/2012

"In a few quick strokes, you can see who I am. Very simple. But underneath what you see, I am so much more." (From Lisa's mother, Catherine D'Agostino) Lisa was a Pine View High School student accepted into the Ringling College of Art & Design. She was diagnosed with depression/anxiety, bipolar disorder and schizoaffective disorder. She died by suicide at 18.

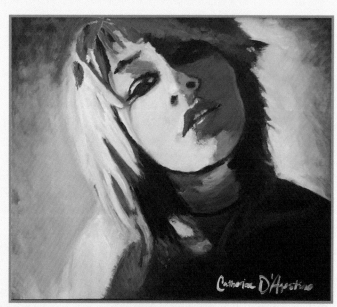

PORTRAIT OF LISA

CATHERINE D'AGOSTINO

"Prone to darkness and also a great light. The dark side was frightening. The bright side, magnificent. But the whole person...always, ALWAYS beautiful beyond words."

CARRIE SEIDMAN

"This portrait represents the hundreds of details I tried to cram into my head in order to organize and roll out the FACEing Mental Illness project and events. Overwhelming me and exacerbating my tendency to anxiety, they often resulted in a stream of tears."

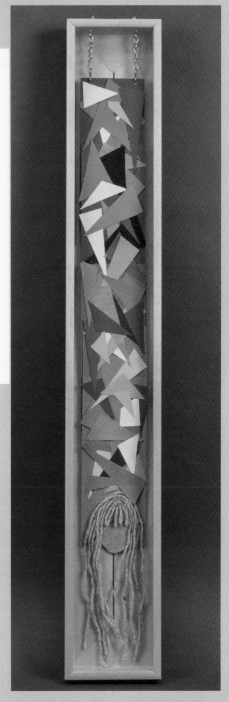

TITLE: WOMAN ON THE VERGE

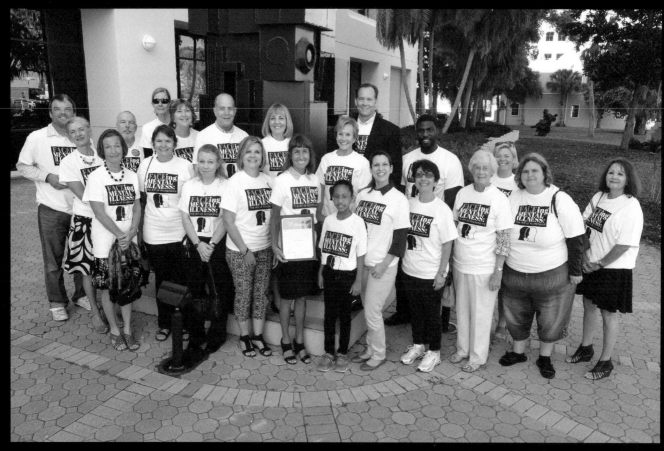

Photo by Dan Wagner

Supporters of the FACEing Mental Illness project gather at the Sarasota County Commission Building for the official proclamation of March 2017 as 'FACEing Mental Illness Month.'

ACKNOWLEDGMENTS
Special thanks to:

The Carter Center for Mental Health Journalism

The Sarasota Herald-Tribune

The Charles & Margery Barancik Foundation

The Gulf Coast Community Foundation

Sarasota Country Libraries

See the entire project online at http://faceingmentalillness.heraldtribune.com

CPSIA information can be obtained at www.ICGtesting.com
Printed in the USA
LVIW01n1825050817
543942LV00001B/1